The Little Black Dress

"It is as if each of us has one titular robe,

and it is

hat special black dress
　　　　that is both chic and armor."

—*Edna O'Brien*
Mirabella, June, 1994

The Little Black Dress

Amy
Holman
Edelman

SIMON &
SCHUSTER
EDITIONS

SIMON & SCHUSTER EDITIONS
Rockefeller Center
1230 Avenue of the Americas
New York, NY 10020

Designed by Eric Baker Design Associates, New York

Manufactured in Canada

10 9 8 7 6 5 4 3 2 1

Library of Congress Cataloging-in-Publication Data
Edelman, Amy Holman.
 The little black dress / Amy Holman Edelman.
 p. cm.
 Includes bibliographical references.
 1. Fashion — History — 20th century. I. Title.
GT596.E34 1997
391'.2'09049 — dc21 97-24635
 CIP

ISBN 0-684-82232-6

Photography and illustration credits appear on page 156.

Acknowledgments

If writing this book has been a special experience for me, it is because so many people were generous with their time and support. First and foremost, I want to thank Rochelle Chadakoff. Her humor and talent made this book better than it would have ever been without her. To my family and friends, Ceci Bennett and her friend Mary Furnary, Annette Dennis, Cindy Erdesohn, Dr. Ellen Fenwick, Dorothy Gabriner, Mirjana and Tatjana Gall, Donna Benner Ingber, Wayne and Diane Jarrett, Nancy Schwartz, Jacques Babando and Veronique Vienne, for their love, patience, support, editing, and baby-sitting services.

I want to thank the people who made time to be interviewed and, where applicable, the public relations people who helped make it possible. They include Letitia Baldrige; Robert Best and Suzanne Segelbaum; Helen Gurley Brown; David Chierichetti; Grace Coddington; Leatrice Eiseman; Michael Eisenhower, Hubert de Givenchy; Eleanor Lambert; Donna Karan, Patty Cohen, and Ilene Wetson; Karl Lagerfeld, Arlette Thibault, and Alexandra Sagano at Chanel; Richard Martin; Polly Allen Mellen; Nolan Miller; Isaac Mizrahi; Ron Protas; Ellin Saltzman; Vera Wang and Tory Robinson; and Linda Wells.

A heartfelt thanks to the people and companies who so generously provided me with photographs and illustrations including Bryan Bantry and Patrick Demarchelier, Serge Gall, Edward Gorey, John Locke, Suyeko Sue Sunami, Steve Wisbauer, Calvin Klein, Nick Knight and Emma, Ralph Lauren, Peter Lindburgh and Chris Schramm, Roxanne Lowit, Isaac Mizrahi, Flora Beth Kenyon, Alex Katz and Diana Bulman at the Robert Miller Gallery, Michelle Stein at Moda & Company for Moschino Couture, Tara Neville at Barneys New York, Dianne Nilson at the Center for Creative Photography, Saline Overton at Condé Nast London, Stephanie Piro, Sevenarts Ltd., Sotheby's, Joe Richardson, Robert Risko, and Maurice Vellekoop.

The photo/illustration research of this project would not have been possible or half so much fun without the assistance of Lorraine Mead at Condé Nast Publications and the "insiders" at the Condé Nast Library; Laurie Bliss and Lauren Purcell at *Harper's Bazaar;* Ron, Howard, Ed, and Adam at Photofest; Michael Schulman at Archive and London Features.

And last, but certainly not least, to my remarkable agent, Lisa Bankoff. Her belief in my talent has spanned decades, and also, to her sympathetic assistant Abigail Rose, whose shoulder was available when Lisa's was not. And at Simon & Schuster, my thanks to Bill Rosen, Anne Yarowsky, and Melissa Roberts.

To my husband, David, and my daughter, Sophie
My grandparents Miriam and Sol Berman
and
In memory of my Aunt Connie, who,
in or out of a little black dress, was quite a dame.

Contents

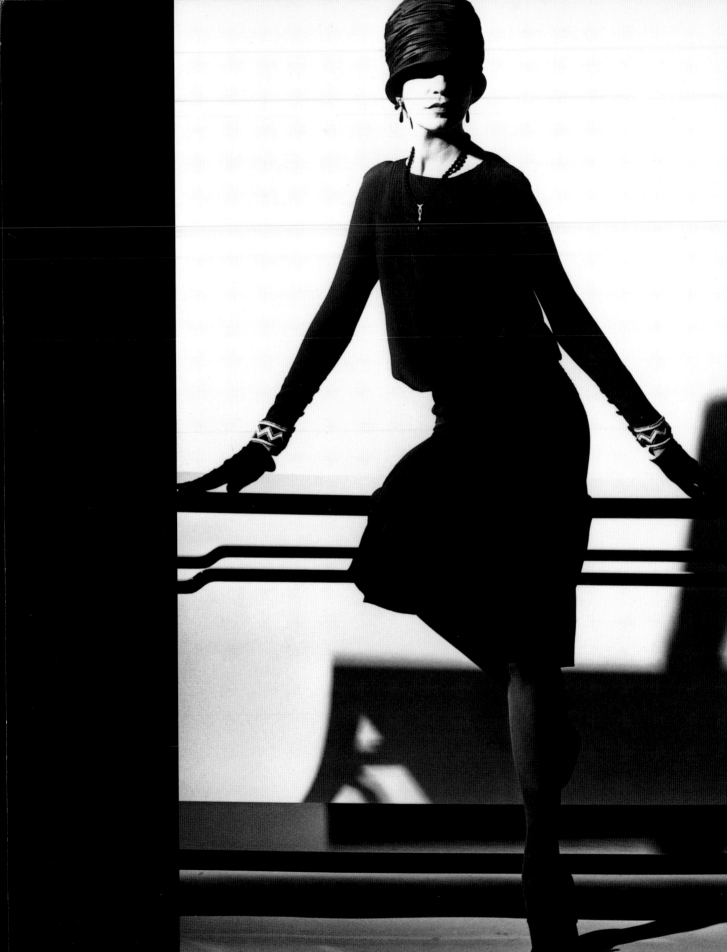

"Scheherazade is easy. A little black dress is difficult."

— Coco Chanel

The Birth of the Little Black Dress

Why is it that whenever a woman wants to feel alluring, she reaches for a little black dress? What makes a simple sheath—devoid of ornamentation, the color of mourning—so luminous? Why is it that a little black dress seems so familiar while at the same time so mysterious and seductive?

The Dawn of a New Dress

The first little black dress is most often attributed to Gabrielle "Coco" Chanel, appearing via a simple illustration in the May 1926 issue of American *Vogue*. The dress, meant to be worn during the day and personalized by its wearer, encouraged comparisons to Ford's shiny black standardized motor car. Both were sleek and represented a concept available to the masses. *Vogue* magazine predicted the little black dress would "become the sort of uniform for all women of taste."

By the mid-twenties, women were gaining a new independence in their lives and mode of dress. No longer just observers, women's increasing participation in outdoor sports and their entrance into the workforce signaled a change in the

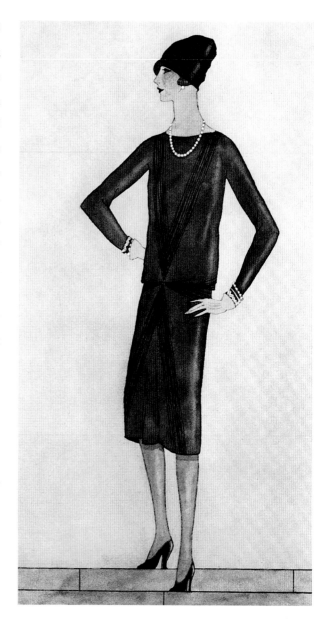

The original little black dress:
When this illustration first ran in 1926,
Vogue called it CHANEL'S "Ford."

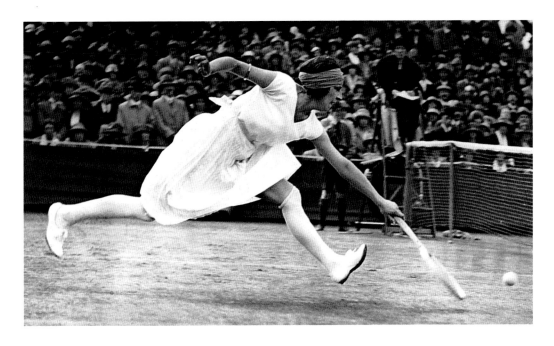

S U Z A N N E L E N G L E N dives to return a shot at Wimbledon in 1922 wearing a *sportif* Jean Patou ensemble.
A new casualness and comfort in women's clothing arrives on and off the court.

status quo. The trend toward a simpler yet more versatile wardrobe was hurried along as couturiers began making chic dresses from utilitarian—and comfortable—fabrics such as jersey, once reserved for men's underwear. A role model for the new sportif look was found in tennis star Suzanne Lenglen. She appeared at Wimbledon in 1922, clothed by Jean Patou in a dress architectural in its lines and renowned for its style.

According to Meredith Etherington-Smith in *Patou,* "Chanel tended to dress the more intellectual members of this new society and those of the old guard with careful pretensions to modernity. Patou claimed the international café society good sports. His women moved!" The restraint of Patou's designs were balanced by eye-catching details— the Cubist-patterned sweater, the first designer monogram, the cardigan sweater worn atop a pleated skirt—and a flair for self-promotion. With Elsa Maxwell, party planner extra-ordinaire, Patou created the fashion show as special event and invented the celebrity model. In 1925, decades before Ralph Lauren's Polo Sport, Patou opened Coin des Sports, a shop specializing in clothing and equipment worn for athletic activities. That same year he created the first unisex perfume, Le Sien, with the reasoning that, "Sport is the territory where men and women are equal."

Patou reached the height of his career in 1924; during the second half of the twenties he reigned supreme. His clients included society ladies, aristocrats, and great beauties of the time including Mona Harrison Williams, Gloria Swanson, Lady Diana Cooper, and

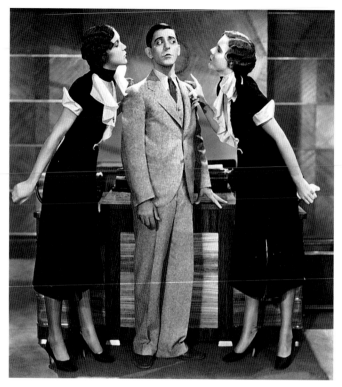

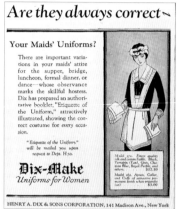

Louise Brooks. A handsome ladies' man and notorious gambler, Patou's persona only added to his allure.

Chanel and Patou were great rivals, primarily because their styles were so similar. In the opinion of writer Anita Loos, however, there was no comparison. "Patou made Chanel look like a milliner. He revolutionized the way women dressed . . . before him it was all ruffles and flounces and after it was clean and elegant."

An article in *Harper's Bazaar* noted that, "Since the war [World War I] . . . there is no denying the tendency has been to give women clothes that are less important than themselves. This, of course, is the result of the greatly increased importance of women in the scheme of things in general. While she was a 'chattel' she had to wear impressive and prominent clothes, so that men would not overlook her altogether." The irony is that as women became more important, their clothing became less so. That a little black dress gave a woman room to define herself set it apart from the overly done costumes that came

Above: CHANEL adopted details from ordinary items of clothing such as maids' uniforms (right) and incorporated them into her designs. The dresses in this movie still (left) from *Palmy Days* (1931) were designed by CHANEL.

Opposite: COCO CHANEL as photographed in 1935 by Man Ray. Her own sleek, chic personal style gave form to the clothes she designed.

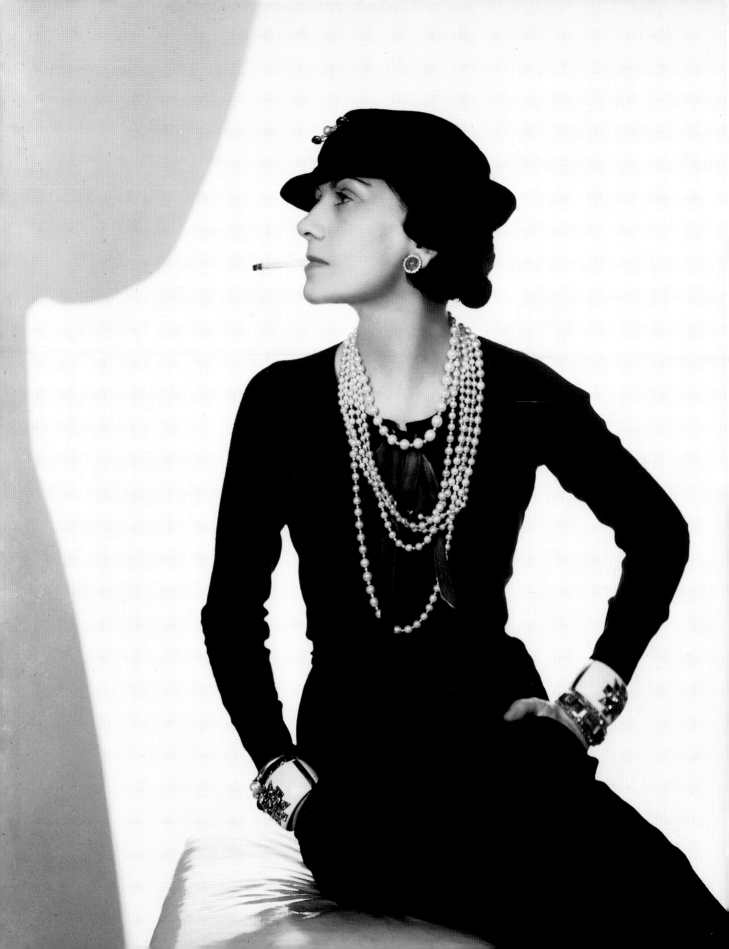

before. It took a combination of factors—including the right time, the right designer, and the right black dress—to create an "immediate classic."

The Right Designer and the Right Black Dress

Gabrielle "Coco" Chanel began her fashion career in 1912, making hats for divas and women of the *demi-monde*. By 1916, the milliner had become a *couturière*. Chanel was inspired by many things and seized ideas from many muses. Her ability to take an idea, shape it for the contemporary woman, and pronounce it her own remains one of her most lasting legacies and the essence of her brilliance. Her short haircut was first seen on the French writer Colette, and many of Chanel's *sportif* looks were first conceived by Patou. By the mid-twenties, she already had a reputation for borrowing items of clothing from other genres—from menswear to sportswear. Even Karl Lagerfeld, reviver of the House of Chanel, disputes the claim that the designer created many of the items for which she is most known. He says, "Chanel copied everything she did and made it commercial. But this is genius, no?" Her strengths, Lagerfeld adds, were "her assimilative knack, her will to change, and her ability to be of her time." It is further testimony to her little black dress that, although others existed before, hers is the one by which they are defined. Richard Martin, curator of the Metropolitan Museum's Costume Institute, thinks that Chanel is most often credited with the creation of the little black dress because it's so easy to assimilate its characteristics into her philosophy of style. In 1923, Chanel told *Harper's Bazaar* that

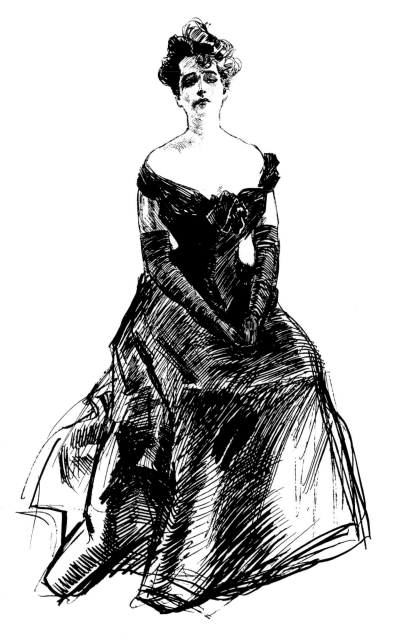

Left: Life before the little black dress. A Gibson Girl dressed for an evening on the town wears a black gown with deep décolletage, a narrow waist, and a bell-shaped skirt.

Opposite: A pre-Chanel version of a little black dress, as drawn by ERTÉ in 1921.

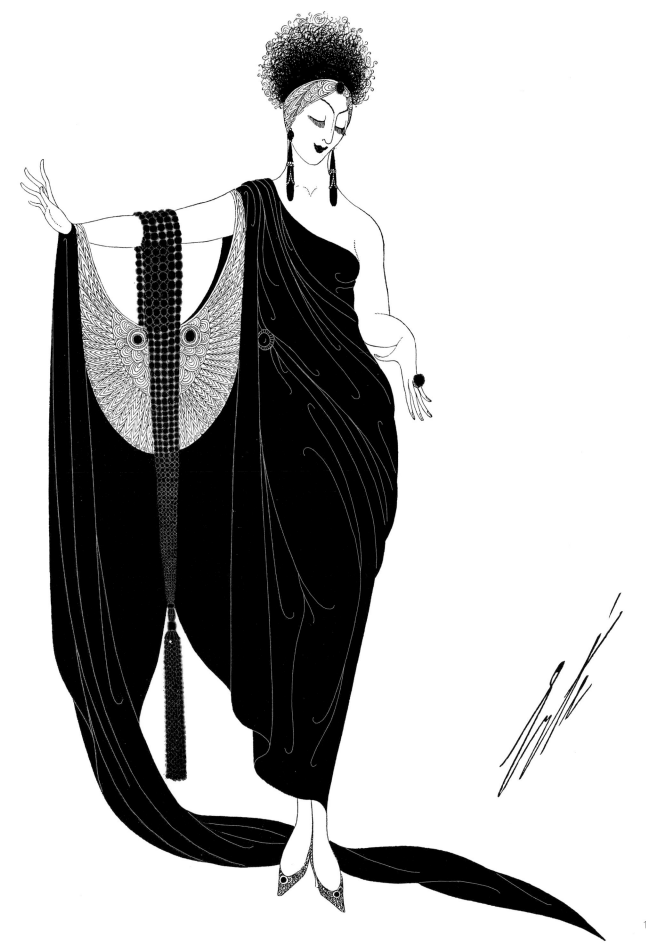

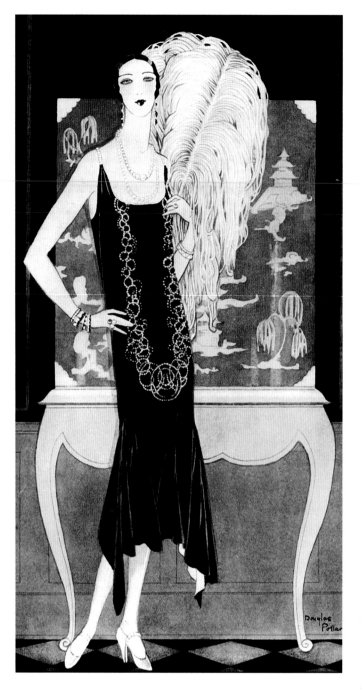

"Simplicity is the keynote of all true elegance." To her, modesty was the chicest way of proclaiming one's superiority. She wanted to get rid of everything that put women at the mercy of convention, that got in their way, that slowed them down. The little black dress was not merely another design for Chanel. It was part of a larger idea, an idea whose roots were firmly planted in the designer's childhood—the details of which she preferred to keep a secret.

Gabrielle Chanel was born in the mountains of Cévennes, in a small, provincial French village, on August 19, 1883. Her parents were not yet married. Chanel was only twelve when her mother died in childbirth and her father, a traveling merchant, wasted little time dispatching her and her sisters to a nearby orphanage. Edmonde Charles-Roux notes in *Chanel and Her World* that, "The vast halls, vaulted corridors, and echoing stairways of this monastic building . . . swarmed with black-clad orphan girls, whose sad existence Gabrielle and her sisters shared for six years."

Chanel left the orphanage at eighteen to continue her education at a boarding school in Moulins. It was here, among young girls of means, that she first discovered cloth-

ing's power to separate and define. Paying pupils arrived at school with plentiful wardrobes in fine fabrics; those attending as wards of the state wore garments knitted in the convent's workrooms. Chanel spent two years at the school, her uniform a constant and tangible reminder that she was an orphan living on charity. In a way, her little black dress would prove a means for exacting revenge. This was a uniform of *her* choosing, which women of wealth and breeding would have to pay Chanel for the pleasure to wear.

Outside the convent walls, there was even a greater distinction between those who had money, breeding, and social position and those who did not. According to *Patou*, "In the world of the belle epoque there were two careers open to women of wealth or women who wished to acquire wealth: to be married or to be a coquette. Women were kept, and fashion reflected this by turning women into walking, or rather hobbling, displays of wealth." At the early turn of the century, there was no mistaking respectable women, *le monde*, with *le demi-monde*, the mistresses of wealthy men who dressed themselves in the elaborately fashionable clothing and hats of the period. Chanel was of the latter group—a "kept" woman by the time she was twenty-five—set apart by the simplicity of her dress and unique style.

When designer Paul Poiret first made his presence felt in Paris in 1906, women were still wearing corsets, crinolines, floor-length skirts, and hats that weighed as much as small babies. Poiret referred to women of the time as "decorated bundles." But times were ripe for change. The suffragettes were initiating the struggle for equal rights and women were ready for the liberty it would bring them. The ability to move less restrictively in their clothing was but a small part of their liberation.

Today, women often buy clothes because it makes them feel good. The impact of Poiret's designs, and the incentive for wearing them, was more deeply felt. The road to an early twentieth-century women's liberation was constrained by the width of their skirts and the weight of their dresses. From the roughly ten years spanning the outbreak of World War I to 1928, the fabric required for a woman's dress shrunk from 19¼ yards to 7. Freedom from confining undergarments and yards of skirts allowed women to participate in daily life in ways that were impossible before.

Poiret took the first step in revolutionizing women's clothing by eliminating the corset, a claim made by other designers of the period, including Madeleine Vionnet and Lady Duff-Gordon, known professionally as Lucille. With the noted exception of his hobble skirt, Poiret gave women a clothing silhouette that did not demand they refigure their bodies. (The corset from which women finally became free was not laid to waste. The steel was used for weapons during World War I.)

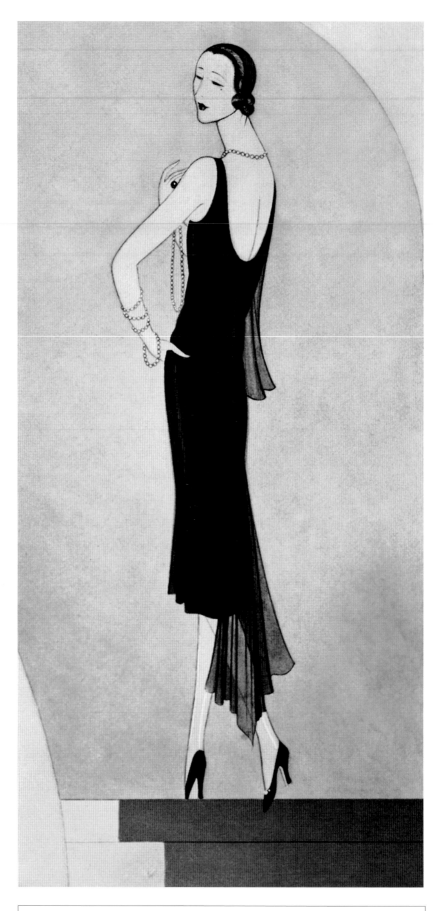

A CHANEL little black dress from 1926 with a bolero top and fish-tail silhouette.

Poiret contrasted his silhouettes with bright, vibrant colors and utilized printed fabrics designed by contemporary artists including Raoul Dufy and Pablo Picasso. His inspirations came from diverse periods and cultures: Napoleonic, Hellenic, Oriental (via Leon Bakst's costumes for the Les Ballets Russes, which appeared in Paris in 1909 and in London in 1911), and the *Arabian Nights*. Although many of Poiret's design ideas were at their basis elaborate, his concept for women's clothing was as simple as it was revolutionary. He said in 1913 that, "To dress a woman is not to cover her with ornaments; it is to underscore the endowments of her body, to bring them out and stress them." Although he would be considered hopelessly passé soon after the war ended in 1918, Poiret's philosophy would stand the test of time.

The end of the War in late 1918 and increasing prosperity in the United States added to the party-like attitude of the early twenties. Grown-ups played, and dressed, like children. According to Etherington-Smith in *Patou*, "There was scarcely any difference between the dress for a child of eight or a woman of eighteen, thirty or sixty." As the decade progressed, waistlines disappeared, as did the bust, and skirts grew shorter. Hemlines barely hovered above midcalf and the *Survey of Historic Costume* noted that, "Never before in the history of costume in the civilized West had women worn skirts that revealed their legs."

For those who could afford it, the 1920s lifestyle was one of adventure and play. High society amused themselves with theme parties, costume balls, and an almost constant flow of champagne and cocktails. Newly constructed ships made traveling easier and society wandered from the French Riviera to Palm Beach, Florida. The growing influence of jazz lent a sexy urgency to an already energetic pace and *Vogue* reported in 1925 that, "Our books, our clothes, our life, as well as our music, grow each year more syncopated." Although fashion dictates emanated mainly from Paris, they were influenced along the way by imports from Harlem and Hollywood. In 1922, Victor Margueritte's novel *Une Garçonne* introduced a female character who bobbed her hair short and dressed like a man. Androgyny became the password of the day.

The Depression and Prohibition caused a further change in the mode of dress, bringing with it a moral revolution as well. The rules written by conservative society were no longer heeded, especially those pertaining to women. Valerie Steele says that, "The feminine ideal of the Twenties was not so much 'boyish' as youthful. . . . In the Twenties, as young women began to lead more active, independent lives, *they* became fashionable society's trend-setters." *A Survey of Historic Costume* notes that, "Until the first World War there were certain standards of behavior expected of 'ladies.' They were not supposed to

smoke, to drink, to see young men unchaperoned, certainly they were expected to kiss only the boy they intended to marry. By the 1920s all this had changed. The flapper, as she was nicknamed, seemed free from past restraints. She smoked and drank, she necked in parked cars, she danced the Charleston until all hours of the night, and what's more she looked totally different as well."

It was Chanel's contention that she dressed to please herself. If a particular fashion did not suit her, as during the belle epoque, she invented something else. Chanel was a woman of her time, struggling to be independent of men while retaining her desire to be attractive to them. Her career was made possible by the financial support and sartorial inspiration of the men in her life. Speaking to Salvador Dalí about lovers Etienne Balsan and Arthur "Boy" Capel, she remarked that, "I was able to open a high-fashion shop because two gentlemen were outbidding each other for my hot little body."

Most of Chanel's innovations in women's wear—white collars, neckties, thick cardigan sweaters, and the use of Russian embroidery and Scotch tweeds—can be traced directly to the clothing she found in her boyfriends' closets. Inspired by menswear, Chanel's first concern was comfort. To her, sensibility equaled sensuality. And sensuality equaled black.

It is almost certain that part of black's appeal to Chanel lay in its practical nature. Her proclivity for the color is also ascribed to her mourning the death of her British lover. According to *Chanel and Her World*, "Gabrielle Chanel stated upon a number of occasions that she had loved but once in her life and only once had known a man who seemed created for her: Arthur Capel. And it is certain that for once she spoke the truth." Some people say that her "desire to put the world into mourning for him" led her to create the little black dress. Although the notion is a romantic one, his death occurred seven years before Chanel's little black dress became a fashion statement.

Chanel's dresses were unmistakably expensive and constructed in the best traditions of the haute couture, but their influence was felt far beyond the world of those who could afford them. In an interview in a 1923 issue of *Harper's Bazaar* she states that, "My establishment is a *maison de luxe*. It caters to the women of leisure only, to those whose atmosphere is pervaded by luxury. I am not interested in any work done for the masses, nor in any work produced in quantities, or at a cost available to all. I want to sell to very few, remain prohibitive. Yes, it is true my models are widely copied. But I don't worry or complain about it. Why should I, in fact, try to prevent this? Think of the publicity it gives me. . . . The women I wish to dress evidently don't care for copies. . . . In fact, were it not

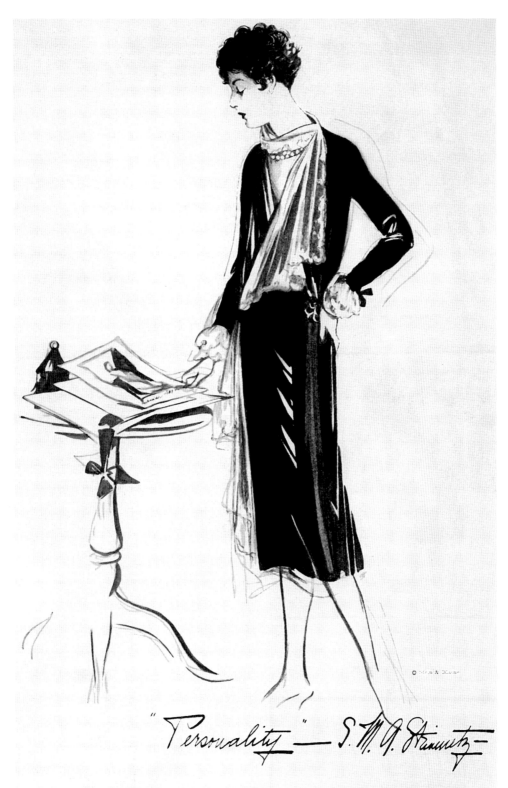

"Personality" — S. M. G. Stanwitz

Stein & Blaine
A CREATIVE HOUSE

13 and 15 West 57th Street
New York

STEIN & BLAINE, a New York–based "creative house," conjured up a little black dress with "Personality" seven months before CHANEL introduced her classic version. There may have been little black dresses before hers, but CHANEL'S is the one by which we define all the rest.

for my unofficial assistants, *mesdames les copistes*, where would all those who want my models, and whom I cannot accommodate, go?"

In 1929, Chanel, along with designers Jean Patou and Lucien Lelong, opened small departments within their couture houses selling ready-to-wear designs. While traveling through the United States in 1931, Chanel had the opportunity to observe the workings of the American fashion industry and mass production. She embraced it, and by doing so, influenced clothing designed for the women who could afford it, as well as for the women who could not. Magazines and newspapers brought fashion to the masses, and the masses wanted to look like the women who wore Chanel. Coco Chanel created the little black dress for the woman of wealth and leisure; mass production enabled copies to reach those who had less.

But both the haves and the have-nots wanted to wear black.

Big Fancy Cocktails and Little Black Dresses

The creation of the cocktail—liquor mixed with syrups and sodas—was one of pure necessity; bootleg liquor was only tolerable when mixed with other ingredients. The cocktail became de rigueur in the Prohibition Era (1920–1933) and the term became an adjective that described not merely a drink but an entire way of life up to and including fashion. When Audrey Hepburn donned her Givenchy in *Breakfast at Tiffany's*, the cocktail dress was already forty years old.

Cocktail parties usually began in the early evening, an aperitif before the nightclub or speakeasy. The ladies-only luncheon and chaperoned tea party became a thing of the past, as did the women who frequented them. The practice of men retiring to the study for brandy while women did needlepoint suddenly seemed old-fashioned. To participate in this new kind of activity, women needed a new kind of wardrobe.

A short, black sheath replaced covered-up floaty tea gowns. With names such as Bosom Caresser and Between the Sheets, the drink (and the dress) erased all thoughts of an earlier age of modesty. Silk charmeuse and crepe de chine columns subtly skimmed the body, allowing for ease of movement; bare arms and a low-cut back exposed newly tanned skin. To complement the clean lines of the dress, ornamentation was plentiful. Long ropes of pearls enhanced the sinuous silhouettes. Cuffs of fake emeralds clasped a wrist while crystals and rhinestones glimmered in the reflection of martini glasses.

Opposite: The little black cocktail dress as drawn by
Edward Gorey in his illustration "Halloween."

"Know first who you are; and then adorn yourself accordingly."

—*Epictetus*

Discourses (2nd c.), 3.1 tr. Thomas W. Higginson

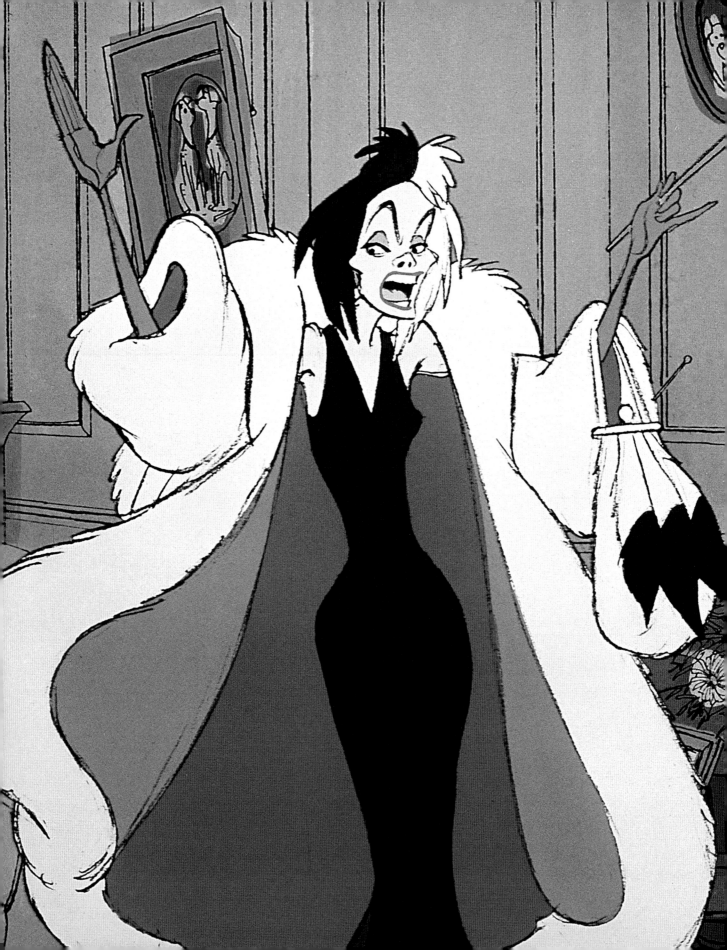

2 Black Magic

Studies have proven that the first thing we notice about clothing is its color. Alison Lurie in *The Language of Clothes* says that, "Merely looking at different colors, psychologists have discovered, alters our blood pressure, heartbeat and rate of respiration, just as hearing a harsh noise or a harmonious musical chord does." When the shade is black, the responses are as multifaceted as they are powerful, based as much on superstition as they are on social history.

Black is the color most often chosen to cloak the pious and those devoted to spiritual sacrifice. It reflects the humility of a nun's habit and the practical endurance of servants and livery. The flip side of black suggests a darker nature. The black arts, black magic, the blackest night—all calling up references to mystery, magic, and, inevitably, a little bit of sin.

Black's association with the wicked and profane enhances its provocative appeal. Lurie further says of black that, "Like white, it is associated with the supernatural, but with the powers of darkness rather than light. The Furies, the three avenging goddesses of Greek drama, always dress in black, and so do witches, warlocks and other practitioners of the Black Arts. And just as white suggests innocence, black suggests sophistication—which, after all, often consists in the knowledge or experience of the darker side of life: of evil, unhappiness and death."

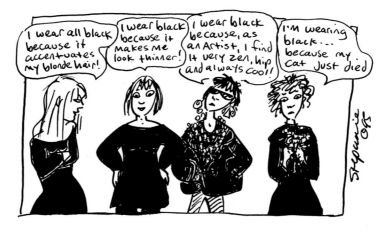

In a 1995 *Glamour* magazine cartoon, women sing the praises and uses of black.

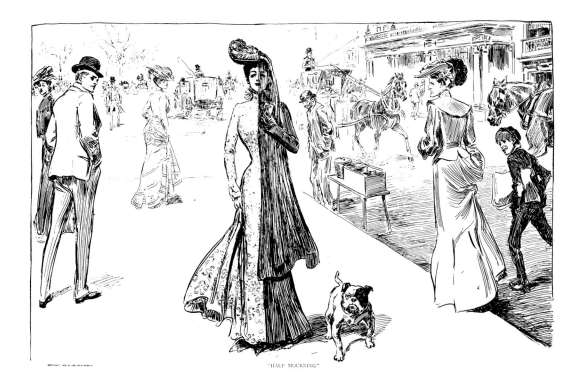

"HALF MOURNING."

Depicted here is a literal interpretation of half-mourning, the period when widows could finally wear colors other than black.

Lou Taylor, in *Mourning Dress*, traces the origins of widows' weeds to the establishment of the first Christian convents, many of which were founded and maintained by wealthy widows who had retired in seclusion after the deaths of their husbands. Mourning wear's seal of approval was granted when royalty, and their attending court, took up the tradition. Fashion was a powerful tool in defining classes and the roles people had in them. For centuries, women were used as a barometer to measure a family's social standing. Their function was negligible when dressed in a garment of shapeless black. And so by the fifteenth century, wealthy widows gave themselves up to the one temptation still available to them—fashion. From then on, widows' dress took on a more stylish air. When the middle and lower classes adopted the rituals—sartorial and otherwise—of the aristocracy, following the correct rules of mourning became a burden for everyone.

The observance of mourning dress reached its peak during the reign of England's Queen Victoria, when in addition to a show of respect, proper mourning indicated a family's wealth and social position. Victoria wore black for over forty years, until her death, in homage to her beloved husband, Albert, who died young and suddenly in 1861. Not even the marriage of her son, Prince Edward, was enough to change

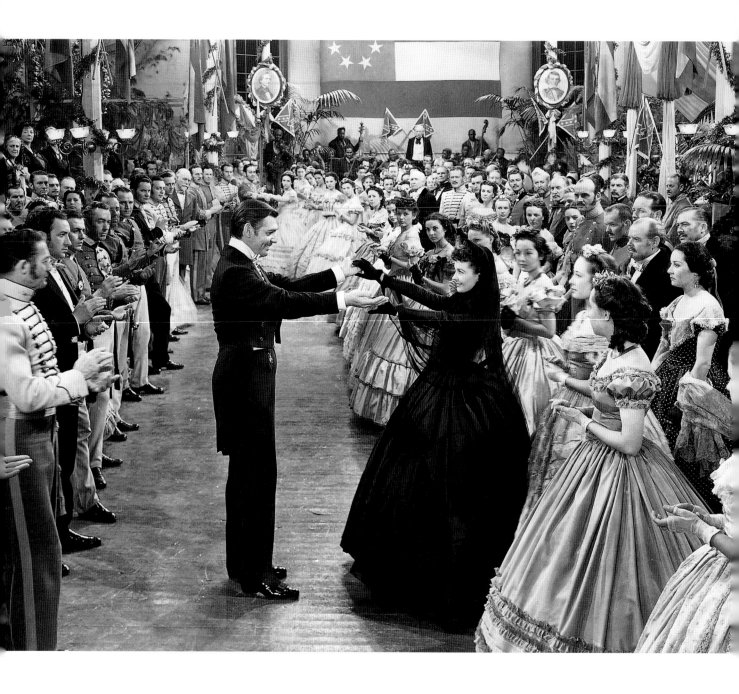

Above: SCARLETT O'HARA
defies convention and shocks the
South by dancing with Rhett
Butler while still clothed in widow's
weeds in *Gone With the Wind*.

Opposite: Mourning wear
was so prevalent that
department stores like
New York's B. ALTMAN & CO.
devoted entire
departments to the
clothing of grief.

the precedent. The queen wore black to the ceremony and the immediate family were clothed in the acceptable royal mourning colors of lilac, white, or gray.

Until the end of the nineteenth century, the loss of a husband dictated that a woman dress in mourning for approximately two and a half years. The first period of mourning, which lasted a year and a day, was referred to as "deep" or "full" mourning and required women to wear clothing of matte black fabric, completely devoid of ornamentation. The second stage of mourning lasted for approximately nine months. Considered too festive for earlier mourning, black silk was now permissible. For the next three months, devoted to "ordinary" mourning, women were allowed to embellish their black dresses with black lace, ribbon, embroidery, and jet. During the final six months of "half-mourning," colors such as gray, white, lavender, or violet could be worn.

The "cult" of mourning was not restricted to Europe and the rules for mourning dress were fully observed in the United States, partly because Americans did not wish to appear less sophisticated than their European neighbors. Many of the details for appropriate mourning wear arrived courtesy of fashion magazines. Like most clothing of the period, styles were determined in Paris and based on the latest trends. As tradition dictated, mourners obtained black clothing for virtually every member of the household, including the domestic staff. Those who could afford to had their mourning wardrobes made to order. Those who could not relied on burial or funeral societies, which in addition to a coffin and a burial plot, sometimes provided the widow's mourning clothes as well.

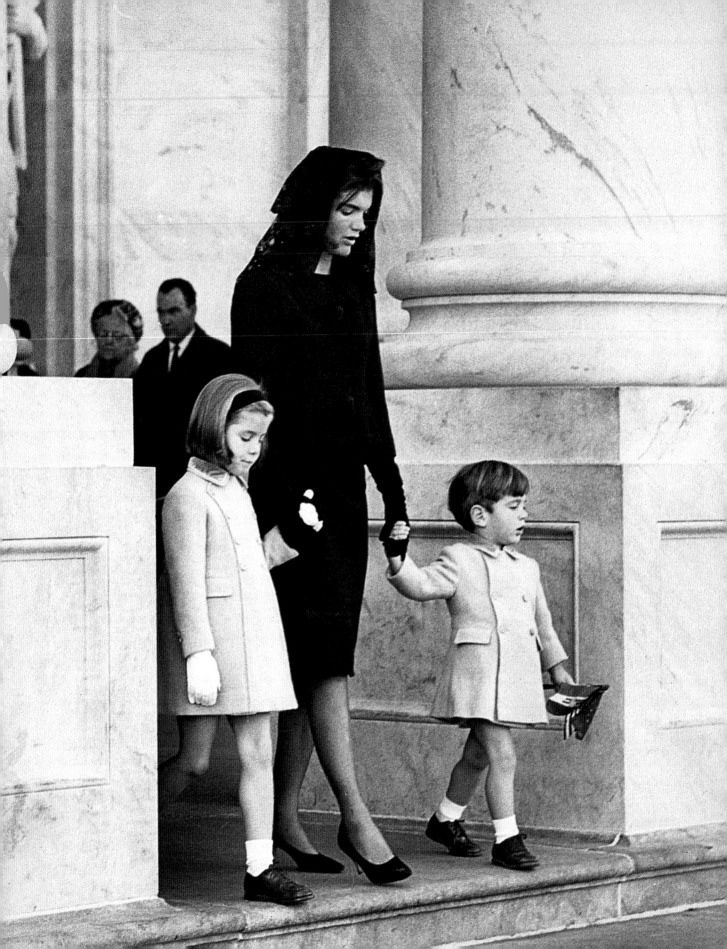

For many women, the laborious observance of mourning was a confinement far worse than any corset. Widows were considered outcasts of proper society, unable to own or inherit property or even to remarry. Wearing black was believed to make a woman appear less conspicuous while announcing her unavailability. In essence, mourning wear symbolized that a woman's life had ceased to exist when her husband's did. But mourning wear was a mark of something more. Just as the letter "A" branded a woman an adulteress, mourning clothes marked her sexually experienced, yet unavailable. A widow, no matter how young and attractive, was forbidden to form another carnal relationship.

Karl Lagerfeld, a student of fashion history and designer for the House of Chanel, believes that the little black dress is a direct descendant of mourning clothing. Says Lagerfeld, "Dresses before this period were never 'little'—perhaps simple but not 'little.' *Little* black dresses first began to appear around 1918–1920 and I have the feeling they came out of the mourning look of World War I. Women got used to wearing and seeing simple black dresses. When life changed, the little black dress became a flexible fashion item—it could move from chic to sexy."

My Reputation

At the turn of the century, stringent rules were still imposed on codes of dress and behavior. The most innocent situations, if misconstrued, could ruin a woman's reputation in "good" society. Those same rules were imposed on a woman's wardrobe. Décolletage was unacceptable during the day, skirt lengths were monitored to the centimeter, and color choices were dictated by the age and situation of the wearer. This was particularly true of young women, who went from being possessions of their parents to (hopefully) possessions of their mates. An impeccable reputation went far in attaining a good husband, and a woman's virtue was protected at all costs from any hint of impropriety. In art, as in life, this was not always possible.

It's hard to tell what the subject of John Singer Sargent's painting *Madame X* is thinking. The work, first seen at the Salon of 1884, so shocked its audience that it placed Sargent's Parisian career in jeopardy. The Salon was an annual art exhibition that took place in Paris; the subject, Virginie Avegno Gautreau, a married woman of refined tastes and shadowy reputation.

Opposite: A picture worth a thousand words.
JACQUELINE KENNEDY in the black dress and jacket she wore to her husband's funeral.

Carter Ratcliff, in *Sargent,* notes that, "We've forgotten—indeed, find it difficult to imagine—how rigidly decorum was observed just a century ago, no less in Paris than elsewhere. Though Mme. Gautreau's adulteries were well known, thanks to gossip and to scandal sheets, they were not considered a fit subject for polite conversation. It was unthinkable for a painter to offer emblems of her way of life to audiences at the Salon . . . yet that is what Sargent did." Mme. Gautreau is pictured wearing a black dress (which was still associated with mourning) with diamond-studded shoulder straps and a deep décolletage. Mme. Gautreau's mother reportedly claimed of her daughter, "She is ruined . . . she'll die of chagrin." Today, the painting of *Madame X* is recognized as a masterpiece. In its time, the bad woman in the little black dress almost ruined a painter's career.

Babes in Black

In *The Age of Innocence,* written by Edith Wharton and published in 1913, a character asks, "What can you expect of someone who was allowed to wear black satin at her coming out?" Black clothing was considered unseemly on a young woman, suggesting an air of experience that had better be illusion. Black dresses, and black clothing in general, were thought to be the province of widows, women who had been married, who had had sexual encounters, who had lost their innocence. It was partially these things that made the color so appealing to young girls. It was prohibited, it was wicked, and therefore it was sexy. In many ways, these connotations linger, giving the woman who wears a little black dress a sense of "grown-up-ness" and allure. Eventually, the rules concerning mourning wear would be relaxed. The rules concerning young girls and little black dresses would remain in force for five succeeding decades.

Uniform for Seduction

When the little black dress was first introduced in 1926, it was still very much thought of in conjunction with mourning, projecting a certain forbidden allure. An aura of self-possession clung to its wearer like a pungent perfume. The little black dress separated the women from the girls as surely as black hats identified the bad guys in old westerns. A little black dress, even when it was circumspect, soon became a password for maturity, experience, and sex.

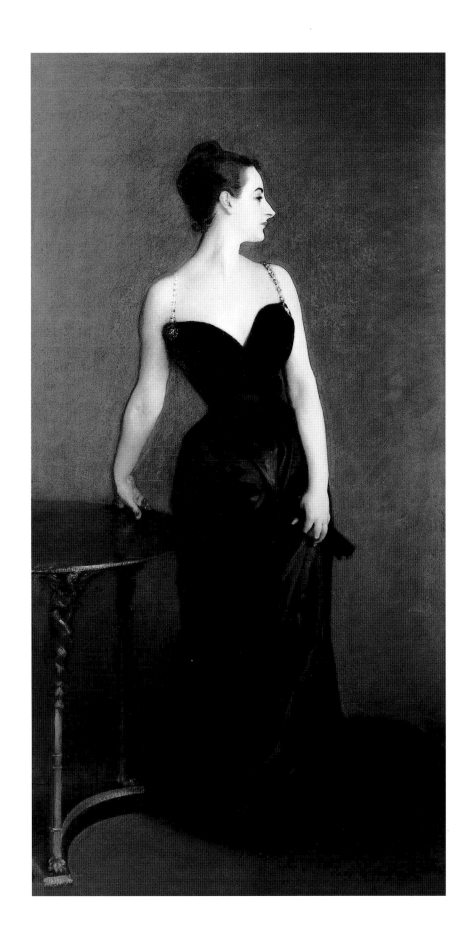

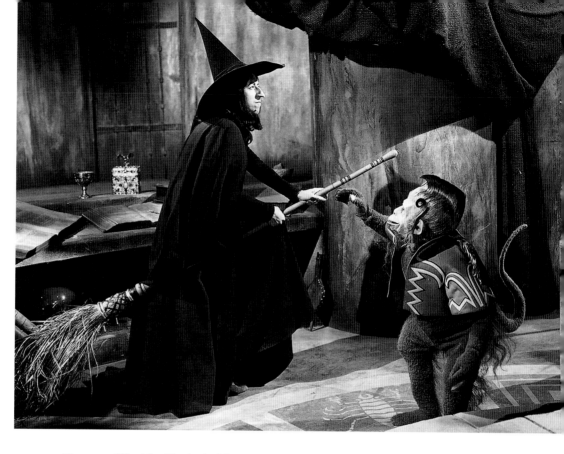

Herman Wouk's *Marjorie Morningstar*, the heroine of his 1955 book, certainly recognized the power of the little black dress: "She picked the black dress off the chair and smoothed it gratefully. It had done its work well. Other girls had floundered through the dance in wretched tulles and flounces and taffetas, like the dresses her mother had tried for two weeks to buy for the great occasion. But she had fought for this tube of curving black crepe silk, high-necked enough to seem demure, and had won; and she had captivated the son of a millionaire. That was how much her mother knew about clothes."

A little black dress would be marked by its seductive powers, both in fiction and real life. In her book *What We Wore*, Ellen Melinkoff recalls of the fifties, "We felt safe with black. It symbolized sexiness and adulthood. Black on young girls was frowned upon. Our mothers told us we would look like old crones in it and forced us into namby-pamby pastels. *They* (and we also) knew black had power behind it. A first black dress was a significant event, a coming out, and no mere girl could pull off such a severe color." In her book, *Love, Loss, and What I Wore*, Ilene Beckerman recalls a tight, strapless dress made from rows of black faille and black velvet, purchased for her by her

Above: MARGARET HAMILTON as the Wicked Witch of the West in the 1939 classic *The Wizard of Oz*.

Opposite: A suggestion of danger and sophistication: a little black dress and a shiny accessory, as drawn by MAURICE VELLEKOOP for *Vogue*.

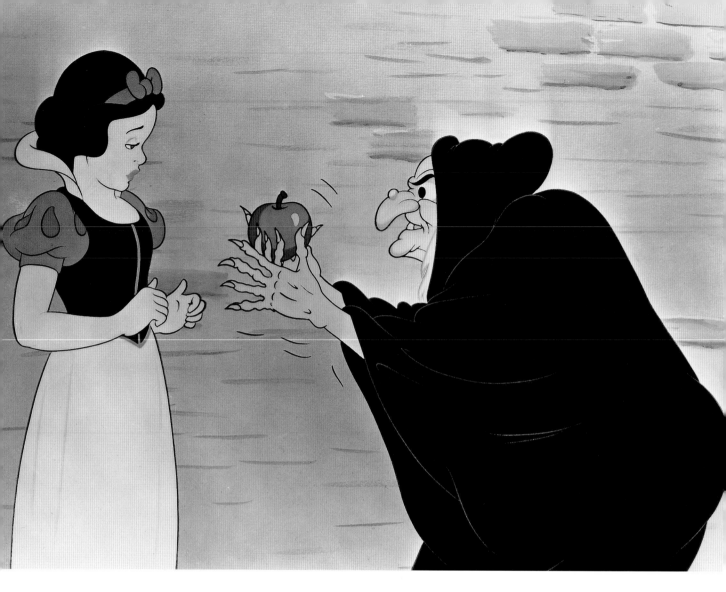

grandmother. She adds that, "The dress was much too sophisticated for a high-school girl, but my grandmother didn't know that. . . . I wore it to a party. . . . I almost got into trouble at that party. I think it was because of the dress."

Clothing entices by accentuating a woman's charms, none quite so successfully as the little black dress. London-based designer Mary Quant, in her book *Color by Quant,* concurs, "Of all the come-hither colours, black is the most chameleon in its sex appeal. It can be all things to all women—and men. It can be demure as in the ubiquitous little black dress that clings with subtle suggestiveness to otherwise unsuspected curves. It can hit the heights of drama in black satin. Black is romantic in lace, voluptuous in velvet, and black fishnet tights as every fancy dresser will confirm are terribly tarty." Actor Walter Matthau put it more succinctly when he told Cynthia Heimel, author of *Sex Tips for Girls,* that "You'll never get laid, looking like that. What you need is a simple black dress."

Sometimes you think pink but wear black

While women's uniform for seduction varies, their color preference is overwhelmingly similar... and for similar reasons. When asked why they prefer black to other colors, women answer instantly that it makes them look and feel thinner. Leatrice Eiseman, director of the Pantone Color Institute, says that, "Most American women feel best when they feel slim and most think that black makes them look that way." Designer Bill Blass echoes the thought. "Psychologically, the black dress makes you look thinner and smaller if you're big, and it makes you feel more important if you're small."

Perhaps it is fitting that Karl Lagerfeld should have the last word on the endurance and changing nature of the color black. From its long association with religious orders and death, Lagerfeld declared of his spring 1995 couture collection for Chanel, "It's not black in the sense of black—it's black in the sense of chic."

Opposite: Black-clad villainess: The evil queen in Walt Disney's 1937 *Snow White*.

Left: Color is key. A Barneys New York ad for an AZZEDINE ALAÏA dress extols the femininity and irresistibility of black.

"It was a warm evening, nearly summer, and she wore a slim cool black dress, black sandals, a pearl choker."

— Truman Capote

Breakfast at Tiffany's

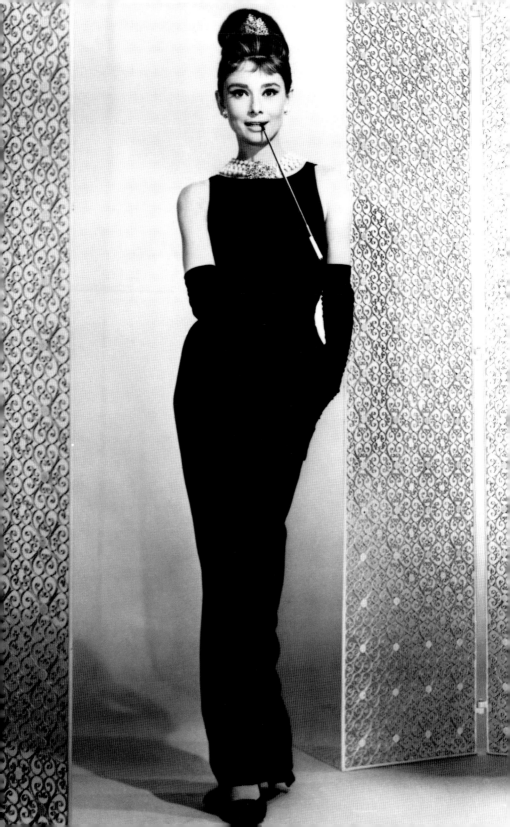

The Little Black Dress: A Classic in the Making

In the seventy years since Chanel "invented" it, the little black dress has continuously found a place for itself among the prevailing fashion. Even during intervals when pants were considered the rage, a little black dress could always be found mixed in with the khakis. Other seasons feature nothing but prints . . . and a little black dress created by a designer who senses that women may crave something simpler.

Just as the definition of style has shifted through the years, so has the designer's response to it. The little black dress has proven to be a common denominator in this century's Rolodex of style. Women have found an item that works in its most stripped-down form—all they have to do is add their individual signature. Let them say—and they have—that brown is the new black or that dresses are passé. The little black dress has proven every one of them wrong, decade after decade.

The silhouette of the little black dress has naturally changed with the times. The range of fabrics, styles, and shapes is staggering—not so surprising for an item that has been around as long as this one has. The little black dress has successfully adapted to the glamour of the thirties, the conservatism of the fifties, the disco-crazed seventies, the glitz of the eighties, and the schizophrenic styles of the nineties. From Chanel's original, to later incarnations donned by celebrities, socialites, and chic suburban housewives, the little black dress is forever changing. Some are long, lean, and glamorous; some are short, sexy, and chic—what they share is the same timeless quality that Coco Chanel imbued in her design over seventy years ago.

The Late 1920s: The End of the Party in a Little Black Dress

The late twenties was a time of great prosperity. The world was changing at a remarkable rate and fashion admirably kept pace. Women had won the vote and could earn their own

> Opposite: A glamorous 1934 cellophane evening dress from ALIX is worn under a cape lined with black seal.

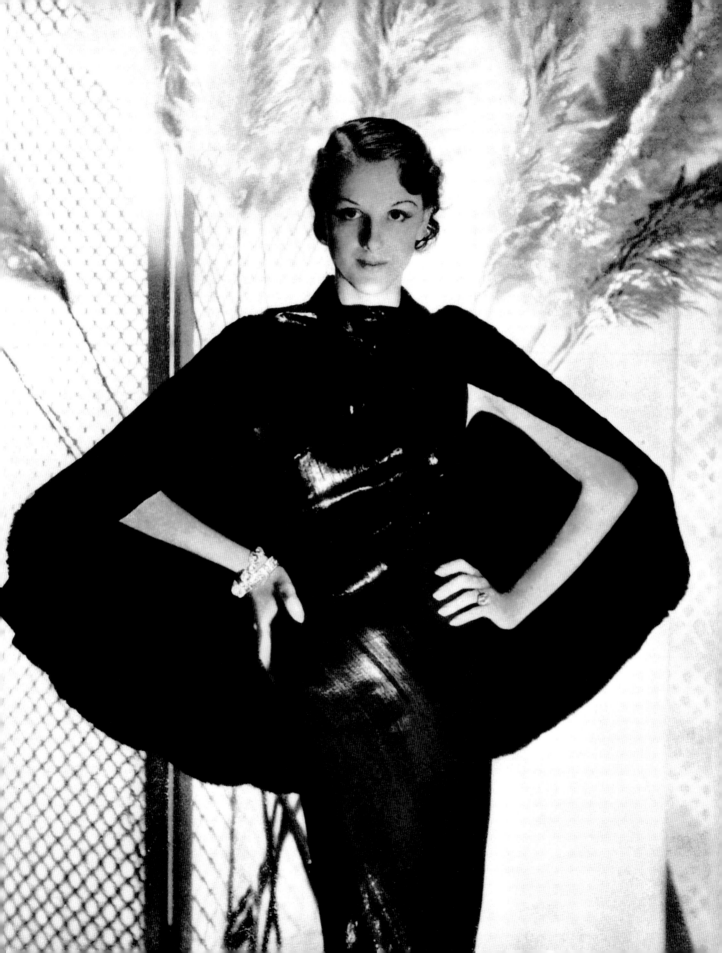

wage; they were no longer confined, or solely defined, by their wardrobe. The androgynous gave way to the feminine; clean silhouettes were enhanced by opulent details. Dresses, sometimes cut on the bias, featured attached scarves or bows and calf-length skirts. Ready-to-wear made fashion increasingly accessible to the masses, but it would soon take a back seat to more important concerns.

The fall of the stock market in 1929 began a depression that affected everyone in the nation. The little black dress shifted into practical mode and was quickly adopted as the uniform of choice. Its sophisticated color and simple lines made it the preference of those who could afford more ostentatious clothing, and especially of those who could not. Women who were struggling to look their best could be sure that their ready-to-wear or self-made little black dresses would not give away too much. The color made it less susceptible to dirt, and it was simple in line, easy to dress up or down. The little black dress would prove itself a woman's wardrobe staple into the coming decade.

The 1930s: Glamour and the Little Black Dress

The thirties began with a depression and ended with a war; the darker colors worn during the period echoed the mood of the times. Hemlines fell with stock prices—day dresses hovered about 10 inches above the ground while evening wear grazed the ankle. The longer lengths were balanced by wider shoulders, flared skirts, and narrow waists. Cloche hats and cowl necklines seemed to droop in response to the general mood.

If you could afford it, your little black dress was cut from fine fabric and embellished with embroidery. It was a quieter, classier way of proclaiming wealth and success, if one was still lucky enough to have them. According to *In Vogue*, "Now that it was in bad taste to look rich, there was a fashion for the 'poor' simple look. Ladies who were still fabulously rich went about in plain black dresses."

The party was clearly over, and with it the party clothes of the previous decade. French couture suffered from the lack of an American clientele. Janet Flanner, Paris correspondent for *The New Yorker*, wrote that, "In the Rue de la Paix the jewelers are reported to be losing fortunes in sudden cancellations of orders, and at the Ritz bar pretty ladies are having to pay for their cocktails themselves. In the Quartier de l'Europe little firms that live exclusively on the American trade have not sold one faked Chanel copy in a fortnight."

Women of all social classes entered the workforce out of necessity. The look of the day was pressed and polished; the clothes were perfect for those who had things to do and places to go. The ideal woman of the mid-thirties showed little resemblance to

the boyish figure of the decade past. She was still thin and long-legged, but in place of a concave chest and linear figure, she yearned for small breasts and shapely hips. She wore makeup and did not care if others noticed; she was self-possessed and incontrovertibly sexy. This sophisticated woman often wore day dresses, which had become notably more severe (the better to highlight her new shapely figure, my dear); the masculine tailoring was partially attributed to Marlene Dietrich's movie wardrobe. Broad-shouldered little black jersey dresses, draped and wrapped across the bodice, were often accented with a white piqué collar and cuffs. The silhouette featured a small, defined waistline and a shorter, narrower skirt. Europe's attention was focused on increased military activity in Germany and Russia, and uniform-inspired details such as epaulets, gauntlet gloves, wide leather belts, and ornamental buttons became prominent.

The dinner dress made its debut at this time, a fill-in for occasions between every day and evening wear. The dress generally fell to the ankle or the floor, but the style and fabrics were far more restrained from those used for typical evening wear of the period. Black was a favored color and the most popular style had sleeves and often matching jackets.

Fashion as Fun

In contrast to the prevalent mood of serious chic, Elsa Schiaparelli introduced the concept of fashion as play. Born in Rome in 1890, Schiaparelli rebelled at an early age against her socially prominent and conservative family. She was sent to a convent in her youth where she promptly staged a hunger strike, resulting in a quick release. She moved to London, married, relocated to New York in 1919, and had a child. Three years after her husband left her, she had saved enough money to go to Paris. Her early efforts at clothing design were unsuccessful, but with encouragement from Paul Poiret, she forged ahead. The popularity of her little black jumpers, knitted with trompe l'oeil bows, enabled her to open a shop on the Rue de la Paix in 1927. Jane Mulvagh noted in *Vogue: History of 20th Century Fashion* that Schiaparelli was initially told that she had "neither the talent nor the *métier*" for fashion design. But by the early 1930s she would become, said Valerie Steele, "the most talked-about couturier in Paris."

In *Elsa Schiaparelli: Empress of Paris Fashion,* Palmer White notes that, "In January 1930 Elsa publicly modelled her first evening gown. It caused an uproar. Starkly simple, it was a plain, figure-hugging, black crepe de chine sheath with the scandalously low 'sunburn' back which she used for her famous swimsuit . . . the dress became one of her most successful designs."

Some of Schiaparelli's most famous pieces were created in the later thirties, in collaboration with artists such as Salvador Dalí and Jean Cocteau. They often featured Surrealist details such as gloves with painted fingernails, a jacket embellished with embroidered hands, and a hat in the shape of a shoe. Schiaparelli was also the first designer to use zippers. The brightly colored fasteners were used as much for their decorative properties as for their practicality. Cocteau once remarked of Schiaparelli's work, "She knows how to go too far."

Schiaparelli's designs are best remembered for their wit, but underneath the tricks were beautifully tailored clothes with a sophisticated line. Schiaparelli, speaking in the third person, once observed, "Curiously enough, in spite of Schiap's apparent craziness and love of fun and gags, her greatest fans were the ultra-smart and conservative women, wives of diplomats and bankers, millionaires and artists, who liked severe suits and plain black dresses."

Chanel dismissed Schiaparelli's talents, partly because the designer garnered so much attention and stole many of her best clients. Their rivalry continued throughout Schiaparelli's career. Bettina Ballard noted of Schiaparelli that, "Looking back over the *Harper's Bazaars* and *Vogues* of the thirties, the hard, highly individual chic of her clothes stands from the pages like a beacon, making the rest of the couture look pretty and characterless."

As the decade drew to a close, the winds of fashion shifted. Paris-designed day dresses showed increasingly feminine touches such as longer, fuller skirts, while in America, the more practical shirtwaist prevailed. Evening wear unanimously favored low-cut, corseted gowns of velvet and taffeta with bell-shaped skirts lined in layers of stiff crinoline. *Gone With the Wind*'s film debut in 1939 did much to further the style. Those not inclined to wearing period styles donned dresses of heavy crepe, bias-cut satin, or columns of brilliant sequins, a fox stole slung casually over the shoulders.

Little Black Dresses and the Women Who Wore Them
Daisy Fellowes

It is Daisy Fellowes who Karl Lagerfeld most associates with the little black dress. In the 1930s, she was known as the best-dressed woman in the world, by virtue, according to *In*

Opposite: In 1936 the DUCHESS OF WINDSOR wore this black jersey SCHIAPARELLI dress embroidered with gilded scrolls.

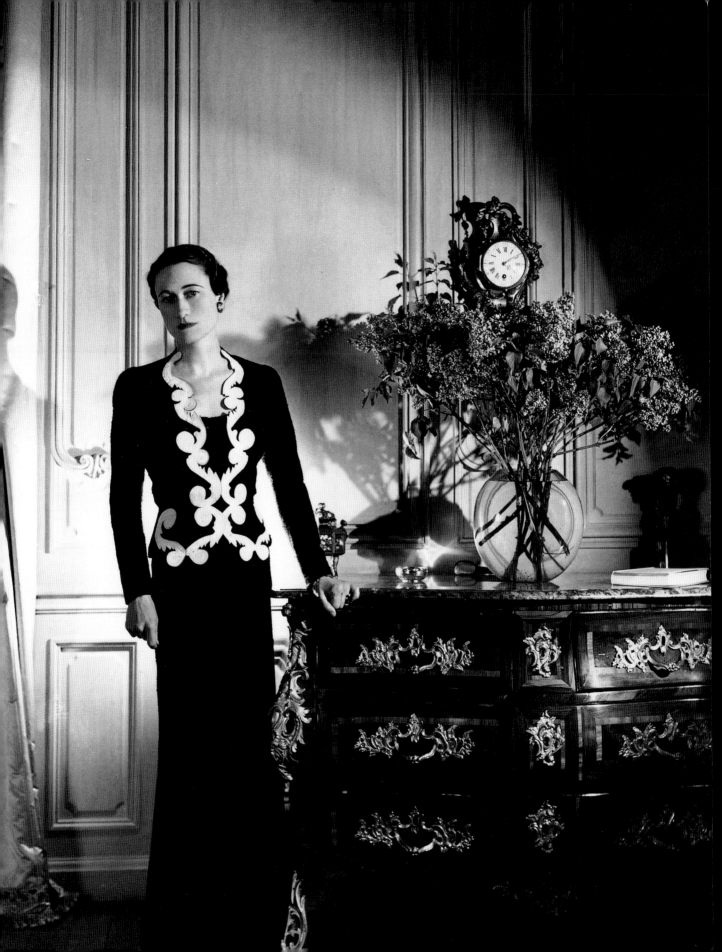

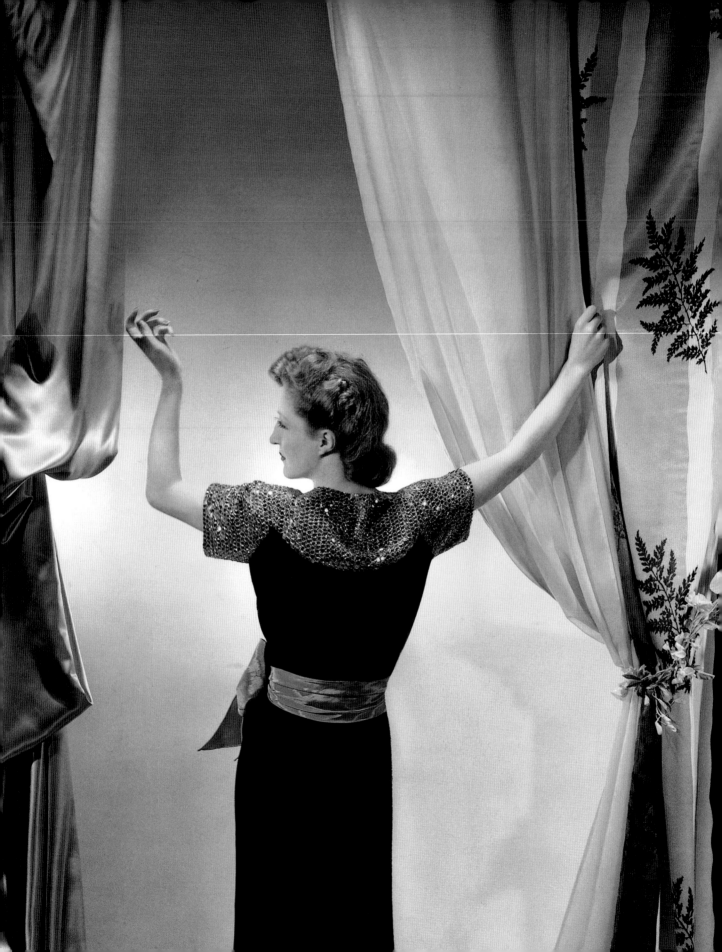

Vogue, of her "insulting elegance that was to be the ambition of model girls up to the 1960s." Heiress to the Singer sewing machine fortune, Daisy was not born a beauty, but she reinvented herself as one. Her secret was her simplicity, described by Cecil Beaton, "as a scrubbed classical look, an unparalleled air of slickness, trimness and cleanness . . . she had the air of just coming off a yacht, which she very likely had." She shopped at Chanel in the 1920s, later moving her allegiance to Schiaparelli. She made a practice of wearing the same plain linen dress, paired with a sequin dinner jacket, a fresh carnation, and an armload of remarkable jewels. When Fellowes once found herself in the same little black tunic as another woman, she cut the ostrich feather trim off her dress and casually used it as a fan.

Wallis Warfield Simpson, the Duchess of Windsor

In was in 1936 that the king of England declared he would rather give up his throne than rule without the twice-divorced Wallis Warfield Simpson by his side. Simpson readily acknowledged that it was not her beauty that claimed the king. The duchess of Windsor was never considered a pretty woman, yet she achieved the illusion of beauty through her inimitable style. She once told professional party giver Elsa Maxwell that, "I'm nothing to look at, so the only thing I can do is dress better than anyone else."

Mrs. Simpson found her haute couture little black dresses at Schiaparelli and Mainbocher, the American-born designer responsible for her trousseau. When Cecil Beaton sketched Mrs. Simpson in 1937, he noted that, "The lighting is becoming and my sitter is at her best in a nondescript black dress that she makes smart by wearing. She reminds me of the neatest, newest luggage, and is as compact as a Vuitton travelling-case."

The 1940s: The Little Black Dress, the War, and the New Look

The forties began with the Second World War taking center stage. Fashion was virtually frozen for the war's duration, as clothing restrictions, bombings, and finally the Occupation of Paris in 1940 kept many couturiers from their work. The United States entered the war when the Japanese bombed Pearl Harbor in December 1941. Due to shortages in the United States and Britain, it became necessary to economize. Eighteen million

Opposite: A 1941 MOLYNEUX dress was made of black rayon crepe at a time when silk was unobtainable due to the war.

women were employed in the war industries and needed comfortable clothing in which to work. Mass-produced items—from weapons to ready-to-wear—proliferated.

Fashion became secondary in most women's lives as the war effort took precedence. The "little" in little black dress was virtually assured, thanks to a U.S. government decree that manufacturers conserve fabric. Wool and silk were needed for the war effort, and so designers worked instead with crepe, velvet, brocade, and satin. Artificial fibers were more widely used, and new synthetics included Orlon (acrylic), Dacron (polyester), and acetates.

Little black cocktail dresses, long-sleeved and high-necked, replaced more formal evening wear, due partly to fabric shortages and the war-charged atmosphere. Plans were made on the spur of the moment, and few women had time for elaborate wardrobe changes; most adapted clothing that had been in their closets at the onset of the war. When new clothing was bought, styles were generally more covered up than their thirties predecessors.

The four years that Paris remained cut off from the rest of the world gave England and the United States an opportunity to show their sartorial accomplishments. Designers from New York to California began to move out of the long shadows cast by the French and in the process created a new category of dress—American sportswear. The Hollywood film industry, at the height of its power, continued to exert its own influence.

Designers making their name in America at this time included Norman Norell, French-born Pauline Trigère, and Charles James. At one time or another they all worked for Hattie Carnegie.

Hattie Carnegie was evidently not familiar with the maxim that a woman had no head for business. Born in Vienna, Henrietta Kanengeiser emigrated with her parents to New York in 1892, only to leave school at age eleven. An admirer of the self-made millionaire and philanthropist, Andrew Carnegie, she adopted his last name when she decided to pursue a career. Lack of design training did little to deter Carnegie from opening a ladies' hat store in 1909. A custom dress shop followed nine years later, and, in 1923, she opened her doors at 42 East 49th Street, off Park Avenue in Manhattan. Carnegie's shop was frequented by socialites and fashion leaders including the duchess of Windsor, Mrs. Harrison Williams, Claire Boothe Luce, and movie stars such as Norma Shearer, Constance Bennett, and Tallulah Bankhead. The Hattie Carnegie "look," which included a number of little black dresses each season, was sophisticated but discreet and often stressed the importance of black as a wardrobe staple.

At the height of her success in the 1930s, Carnegie was selling custom-made and ready-to-wear clothing from the best American and European designers. Her own collec-

tions included Hattie Carnegie Originals, Spectator Sports, and hats under the Hatnegie label. The Manhattan shop also carried furs, gloves, handbags, jewelry, and cosmetics. When Pope Pius XII allowed nuns to update their habits in 1952, Carnegie designed a simple black dress that looked as natural on the runway as it did clothing the order of the Society of Christ Our King. She also had a knack for spotting talent.

Ready-to-wear designer Norman Norell brought couture standards to the mass-market showrooms of New York's Seventh Avenue. Born in 1900, Norman David Levinson studied art at the Parsons School of Design in New York before switching to Pratt Institute in Brooklyn a year later. Norell was a costume designer before moving on to Hattie Carnegie, where he stayed for nearly thirteen years. He showed his first collection in 1941, under the label Traina-Norell. He cut his little black dresses in jersey and crepe, accenting them with simple buttons and collars secured with a bow. Norell became known for his beautifully made, elegant clothing and his shimmering *paillette*-encrusted "mermaid" evening dresses. A master at creating clothing that possessed equal amounts of dazzle and simplicity, Norell earned the title "Dean of American Fashion." He was the first designer to receive the prestigious Coty Award for excellence in fashion and the first to be elected into its Hall of Fame. He launched his own label in 1960.

Claire McCardell also worked for a brief time in Hattie Carnegie's studio and is often credited with singlehandedly creating American sportswear. McCardell designed clothing for the American career woman, a breed distinctly different from anything that had been seen abroad. Born in Maryland in 1905, McCardell attended Parsons School of Design in New York. After studying for a year in Paris, she returned to work

THE JEWELLED COWL;
THE CORSET WAIST

Now, the midriff is lashed to its smallest circumference, many ways. Here, the shape-maker is a firm corset lacing. Now, the pretty area of the throat is decorated to the nth—here, with a jewelled cowl: ropes of pearls and sparklers worn layer upon layer. *Left:* Stitched to a blouse of melting silk jersey, a firm corset of taffeta, to pull in, in, in. The skirt is separate, is silk taffeta too. by Traina-Norell. $295. Gloves by Superb; pearl beads by Richelieu; rhinestones by Bogoff. All are at Bergdorf Goodman; The Blum Store; Neiman-Marcus; I. Magnin. *Right:* Four bow-tied laces hold this dress to the rib cage, and between them is a new area of décolletage. Dress of black silk *peau d'ange;* Herbert Sondheim, $90. Necklaces and other brilliants, by Eisenberg. All, Best's. Everything, including gloves by Superb, also at Hudson's; Thalhimers; Frost Bros.

NORMAN NORELL'S prim version of the New Look came with a built-in corset. Mme. Chanel would most definitely *not* have approved.

for Townley Frocks in 1932 on New York's Seventh Avenue. McCardell was alert to the changes in fashion and the budget of her clientele. Norman Norell once noted, "Don't forget, Claire invented all those marvelous things strictly within the limits of mass production. I worked more in the couture tradition—expensive fabrics, hand stitching, exclusivity, all that—but Claire could take five dollars worth of common cotton calico and turn out a dress a smart woman could wear anywhere."

McCardell went on to become the first ready-to-wear designer with her name on the label. McCardell liked simple, practical, unstructured clothing that retained its femininity. She believed that a woman's own body and choice of accessories brought her clothing to life. McCardell created multi-use, interchangeable wardrobes that worked perfectly with the American woman's active lifestyle. The fabric restrictions and style requirements dictated by the war only served to sharpen her talents. As *Vogue* noted of the modern woman in January 1950, "By 1942 she has worked out for herself a satisfactory way to look—a frugal, spare-silhouetted American primitive look that Martha Graham helps her to visualize, and Claire McCardell and Capezio help her to achieve: her dress a jersey tube with a décolleté daytime neckline . . . her Phelps belt and bag bold . . . ; her feet flat on the ground." McCardell was the first American designer to be featured on the cover of *Time* magazine, in May 1955. Lauded as a "designer's designer" and the first to create clothing for the "suburban lifestyle," her designs look as modern today as they did fifty years ago.

While American talents flourished, English designers including Norman Hartnell, Molyneux, and Victor Stiebel were also making their mark. Although Paris would not give up its claim as "fashion capital" easily, the United States and Britain would establish an independence that continues today.

The Liberation of Paris arrived in 1944. Despite extensive shortages and damage to the city, ensuring the continuation of French couture's prominence became a priority. Thus, immediately after the Liberation, French designers returned to work and with them came updated fashion news. In comparison to the prevailing silhouette in the United States and Britain, Paris dresses looked extravagant and overdone. Jane Mulvagh noted in *Vogue: History of 20th Century Fashion* that, "In France during the Occupation no French woman was allowed to wear a uniform or badge that showed that she was serving

Opposite: The comfortable and inexpensive CLAIRE McCARDELL "baby-doll" dress debuted in 1946.
"Claire could take five dollars' worth of common cotton calico," said Norman Norell,
"and turn out a dress a smart woman could wear anywhere." Photograph by Louise Dahl-Wolfe.
Collection, Center for Creative Photography, Arizona Board of Regents.

her country, so she flaunted the irresponsible, frivolous clothes of a fashionable coquette in front of the occupying forces."

Still staggering from the effects of the war, women in other parts of the world were not quite ready to revel in excess. Consequently, a simple little black dress continued to be a wardrobe staple. According to a 1944 *Vogue*, "Ten out of ten women have one—but ten out of ten want another because a little black dress leads the best-rounded life. Is a complete chameleon about moods and times and places. Has the highest potential chic (only if well-handled). Has the longest open season."

It took French designer Christian Dior to reignite the world of couture by introducing his "New Look," on February 12, 1947. The dresses—which looked best in black—had tiny waistlines, padded hips, full bosoms, and softly rounded shoulders. Skirts were made fuller by petticoats and flounces that fell almost to the calf. Although some restrictions were still enforced, Dior used yards of sumptuous fabrics to create a wasp-waisted silhouette that had not been seen since the late eighteenth century. *In Vogue* reported that, "The New Look provoked extremes of delight in women, for whom each dress and suit was an orgy of all things most feminine and forbidden." Chanel, the doyenne of practical, comfortable clothing, had a different take. She said of Dior, "Was he mad, this man? Was he making fun of women? How, dressed in 'that thing,' could they come and go, live or anything?" Women who had learned to balance checkbooks now concentrated their efforts on balancing in high, slim heels; cocktail hats replaced nurses' caps. The weight of the world no longer rested on their softly rounded shoulders.

Little Black Dresses and the Women Who Wore Them
Pauline de Rothschild

Born in Paris, Pauline de Rothschild was sent to her mother's family in Baltimore when she was seventeen. Interior designer Billy Baldwin recalls first meeting her "dressed in a simple black cotton dress, heavy black stockings, and wore brogues. Her hair was braided into two pigtails tied with black ribbons. Although she was sitting down, it was possible even then to know that she was very tall. Upon our arrival, she decided to unfold herself, which she did like a giant yardstick; she ended up being nearly six feet tall and pounds underweight. She had the palest possible skin, and hair that I can only describe as being hair colored." Although not considered a traditional beauty, Pauline became known for her

Opposite: VALENTINA, clothing/costume designer and social figure, models a dress and dramatic geometric hat of her own design, circa 1940, in this photograph by Horst.

great taste and inimitable style. She worked for Elsa Schiaparelli in Paris and designed many little black dresses for Hattie Carnegie. She met de Rothschild in 1950 and was married four years later.

Valentina

Valentina Nicholaevna Sanina was born in Kiev, Russia, at the turn of the century. She traveled through Europe with her husband, George Schlee, arriving in New York in the early twenties where the couple first began to attract notice, by virtue of his charm and her great style. According to *Vogue*, "Valentina couldn't sew, but she designed her own clothes, and they attracted attention. When all the flappers were wearing short pale chemises, she dazzled onlookers with her high-necked, ankle-length, slim-waisted black velvets that prefigured the dinner gowns of the thirties." She opened her couture business in 1925, creating costumes for Broadway stage actors, film stars, and a socially prominent clientele. Her patrons included Katharine Hepburn, whose costumes she designed for the stage play *The Philadelphia Story*, Gloria Swanson, and various Astors and Vanderbilts. Valentina also designed clothing for neighbor Greta Garbo, reportedly her husband's longtime mistress. Like many of her clients, Valentina's designs were dramatic and one of a kind. She abhorred clothing that was not versatile and that quickly dated. Valentina's work uniform often took the shape of a simple black dress, which when properly accessorized, was suitable for evening wear. Valentina closed her couture business in 1957. Although she is little remembered today, her style and little black velvet dresses helped make her a legend in her own time.

The 1950s: The Little Black Dress Reigns Supreme

The United States emerged from the war years with increased prosperity. For most Americans, the 1950s began as a period of optimism and economic growth. Technology for improved mass market production was fully in place, and a consumer society began to flourish. Fashion had regained its rightful standing in the world, and women responded with pleasure. Men took care of business, and women fretted over wardrobing details. From pillars of strength in a world gone mad, women stepped back into their roles of housewife and mother. They resumed these roles dressed to kill. Mila Contini, in her book *5,000 Years of Fashion,* describes the early fifties as, "a period when the near uniform of a

Opposite: This MAINBOCHER dinner dress from 1952 has a stiff, flared skirt. Worn with the requisite necklace and gloves, it is a classic little black dress of the era.

girlish black dress with white collar and gloves, completed by a pearl necklace, colored shoes and a mink stole, was spreading all over the world."

During the fifties, the suburbs were the destination of choice, and women were expected to be as manicured as the grass on the wide front lawns. Finishing touches were essential. Jewelry, from brooches to cuffs, added sparkle. Flat Capezio ballet shoes were worn for everyday, and strappy sandals or high-heeled stilettos were donned for more formal occasions. In a catalog to a retrospective entitled "Ahead of Fashion: Hats of the 20th Century," the curator of the Philadelphia Museum of Art notes that, "For much of this century, 'the little black hat,' like 'the little black dress,' has been a staple in the well-dressed woman's wardrobe. . . . A black hat capitalizes on the face-framing qualities of the color while expressing the pure form and shape of the object." The text goes on to describe a hat designed by Lily Dache in 1955, calling it "the ultimate cocktail party hat, the perfect accompaniment to 'the little black dress' that was an essential part of every woman's wardrobe during the period."

While wealthy socialites still indulged in the hand-made luxury of couture, standard sizing became more precise, thanks to the production of wartime uniforms. The ability to buy "off the rack" brought fashion closer to the masses, while affordable designer "knockoffs" enabled women of average means to keep up with the fast-moving changes issuing from France. Perhaps in response to its abrupt loss of leadership during the war, Paris reigned as a supreme and fickle fashion dictator. Designers and their collections took turns in the sartorial spotlight. And every change in silhouette or hemline was scrupulously noted in the fashion press on both sides of the Atlantic.

The reporters were present in force when Hubert de Givenchy presented his first couture collection in 1952. He was just twenty-five years old, having decided at ten to pursue a career in design. Referred to as the *enfant terrible* of fashion due to his age and daring inventiveness, Givenchy aspired to the same purity of line as his mentor, Cristobal Balenciaga, designing with an emphasis on shape, not extraneous detail. He came to prominence at the same time as his muse, Audrey Hepburn, who had borrowed a few pieces from his collection for *Sabrina* in 1954.

Givenchy was not the only designer in the spotlight. In 1953, Christian Dior again made headlines, this time merely by shortening women's skirts from their position at the ankle to a few inches below the knee. Chanel, too, made news when she returned from a

Opposite: Four bows secure the bodice of this HERBERT SONDHEIM black silk *peau d'ange* dress from 1952.

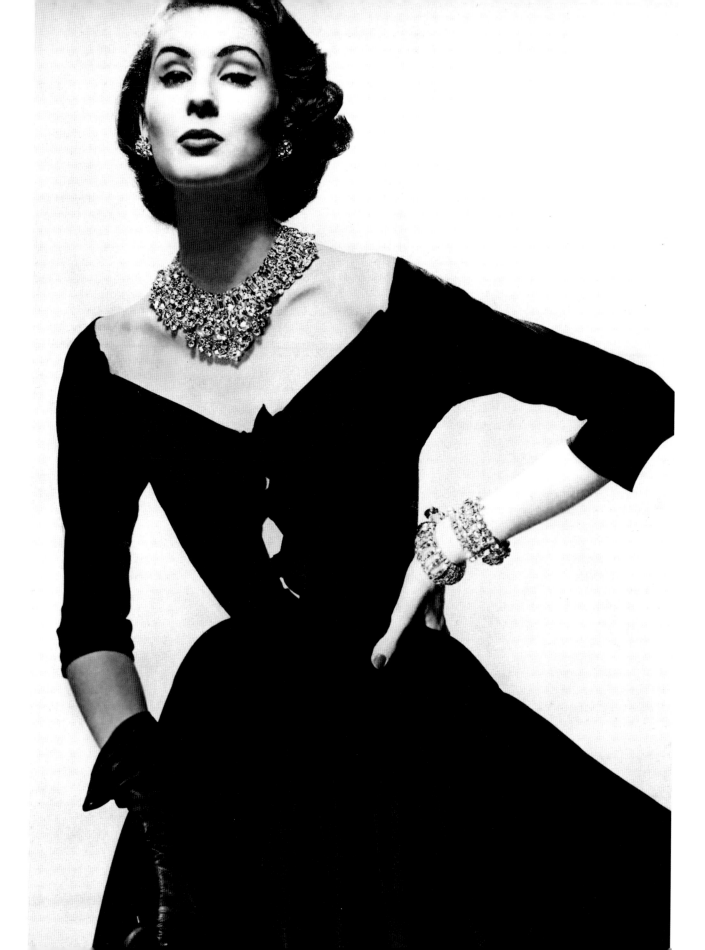

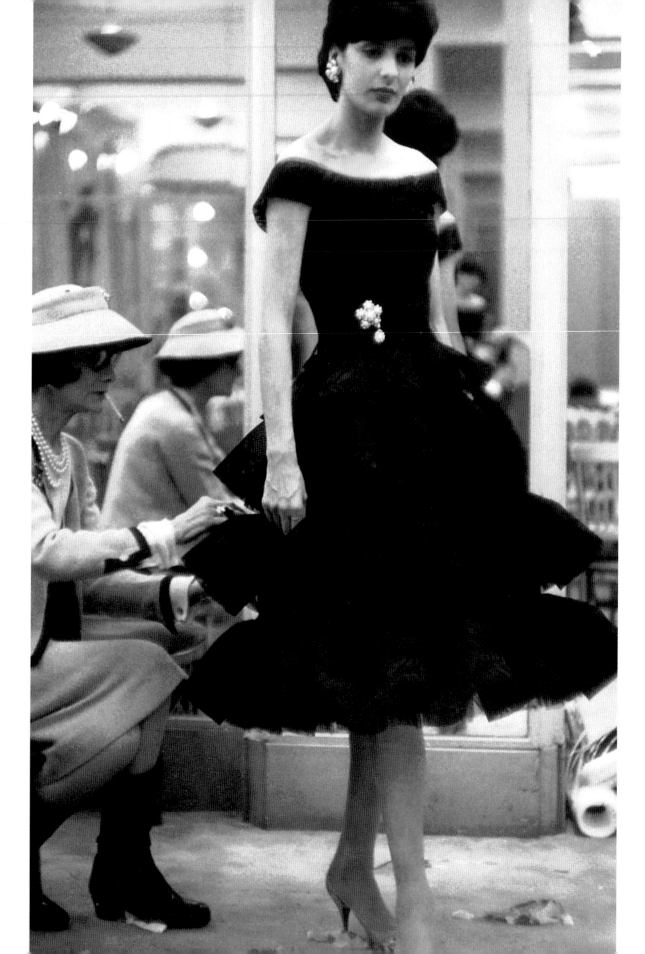

self-imposed Swiss exile to Paris, and to work, in 1954. An affair with a Nazi officer during the war had made her an outcast and, at age seventy-one, few designers considered her a threat. Her new collection was not well received in Europe, and it took three seasons and the enthusiasm of the American market for her work to again be fully appreciated. She continued to offer chic and sensible solutions to what she viewed as fashion's current follies. Upon her return she said, "I am no longer interested in dressing a few hundred women . . . ; I shall dress thousands." *In Vogue* noted that, "It was a time when you couldn't be both fashionable and comfortable, unless you dressed at Chanel. You carried the weight of an enormous pyramid coat and you hobbled in pencil-slim skirts. . . . Collars turned up and bit into the chin, boned and strapless 'self-supporting' bodices made it difficult to bend, corsets pinched the waist and flattened the bust."

By 1955, *British Vogue* noted that, "A significant struggle is taking place in Paris. On the one side there are designers whose achievement is to create clothes of so strong a shape that they look as if they could walk across the room alone . . . on the other side there are designers whose clothes are not superimposed on a body: they have no existence apart from it." The first group included Givenchy and Dior, who created the A-line, a dress silhouette narrow at the top and wider toward the hem; the H-line, which was straight and narrow; and the Y-line, which was broad at the shoulders and narrow at the hem. The second group, championing the straight and narrow, included Chanel and Balenciaga.

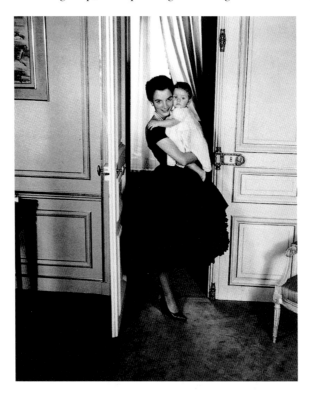

Left:
MADAME PIERRE LE BLAN fulfills all the ideals of fifties womanhood with a baby and a little black dress by HUBERT DE GIVENCHY from his 1957–58 haute couture collection.

Opposite:
COCO CHANEL, seen here in her trademark suit and pearls, fits a little black cocktail dress on a model in 1959.

Cristóbal Balenciaga was considered a genius whose talent for draping and cutting was second to none. According to *Harper's Bazaar*, "Almost every woman, directly or indirectly, has worn a Balenciaga." His sculptural creations, cut from stiff faille and crisp taffeta, enabled the little black dress to take on chic and strange new forms that were less fitted and often easier to move in than other styles of the period. Although he created clothing in beautiful colors (Diana Vreeland once said, "Oh, but the violets. You should have seen Balenciaga's violets."), he harbored a Spaniard's love of black. The centerpiece of each of his collections was a black dress, made entirely by the designer himself. Robyn Healy writes in *Balenciaga: Masterpieces of Fashion Design* that, "The most sophisticated day dresses in Paris are the little black dresses, fitting the figure like a wet glove, unrelieved by any soothing touches, immaculately plain from neck to hem. Most of the big houses show something of that sort, but the best of the school are at the new Spanish house, Balenciaga. Here the black is so black that it hits you like a blow. Thick Spanish black almost velvety, a night without stars, which makes ordinary black seem almost grey." Although other designers created little black dresses, Balenciaga was defined by his.

Christian Dior's sudden death in 1957 stunned the world of fashion, as did the announcement of his successor, twenty-one-year-old Yves Saint Laurent. His first collection launched the trapeze silhouette, which fell from narrow shoulders to a wider hemline just covering the knees. The collection was a huge success, propelling Saint Laurent to fashion stardom. For this feat he was acclaimed for saving Paris. Fashion being fashion, his favor at Dior did not last. According to *In Vogue*, "In the teeth of an unspoken agreement among the couture not to alter a hem length by more than two inches a season, Saint Laurent dropped the hem by three for his next collection. Twelve months later he bared the knees, and caused an uproar." By 1958, couture designers had again reunited, and Paris unanimously decreed hemlines to be above the knee. The following year, Saint Laurent brought back the waist and the hobble skirt. His knee-length dresses did not please the crowds or the critics, and following a stint in the army and a nervous collapse, he was replaced by Marc Bohan, his former assistant at Dior. The accepted silhouette of the period continued to be loose, cinched by a wide belt and falling two and a half inches below the knee.

Hemlines were not the only things changing in the late fifties. In 1957, Dr. Martin Luther King Jr. spread the gospel of equality and Elvis Presley the sounds of rock 'n' roll. The United States entered the space race and *Sputnik I* was launched by Russia. While

Opposite: This 1952 BALENCIAGA creation blossoms out from a fitted bodice and narrows at the hem.

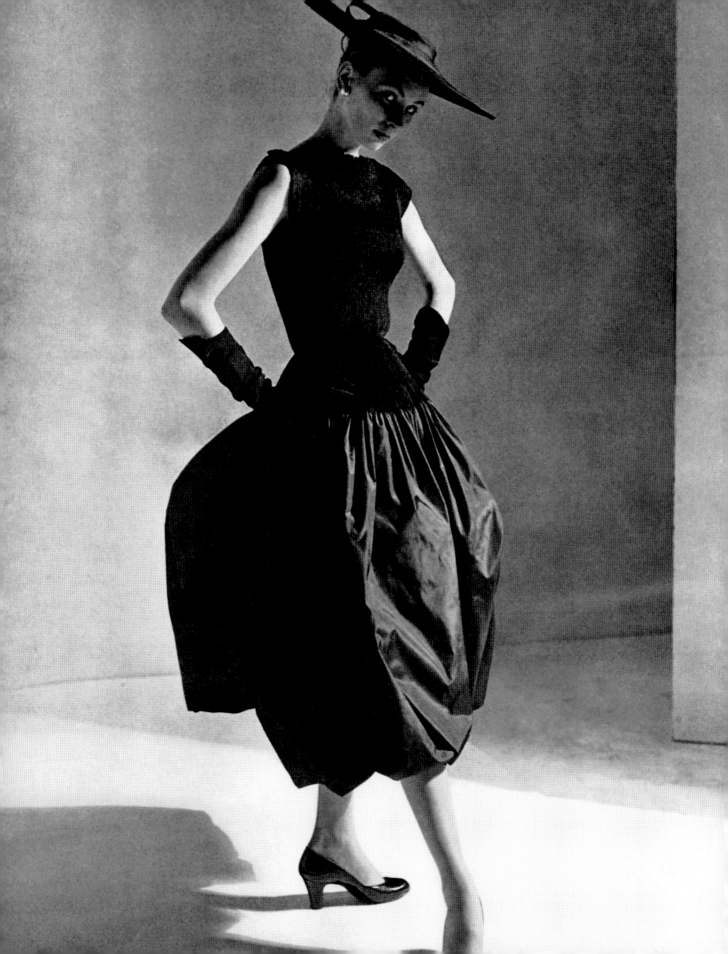

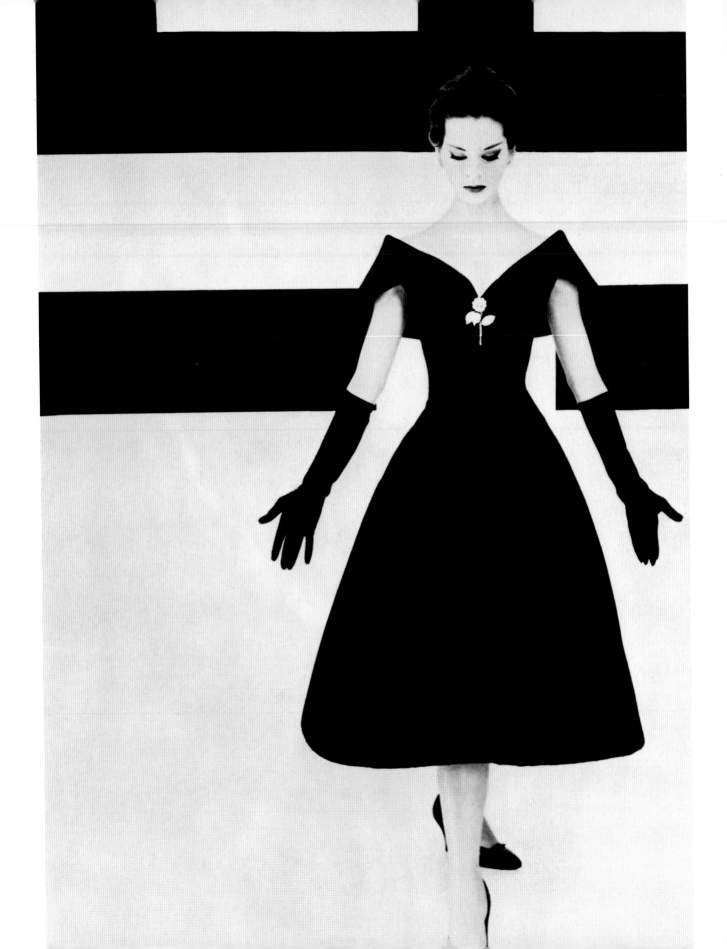

housewives and socialites tried to keep up with Paris, young women began setting their own fashion direction. Beginning in the fifties and picking up steam throughout the next decade, fashion inspiration began to evolve from the street. Young girls no longer aspired to dress like their mothers. In contrast to their parents' philosophy, "nonestablishment" fashion was not determined by a price tag but by the way a "look" was put together. A revolution was afoot. Teenagers, gaining their independence through their ability to earn, spent liberally on products and clothing that was geared for *their* lifestyle.

The beatniks did not start out to influence fashion. The group began life on the Left Bank in Paris as an artist's and writer's movement that included Jack Kerouac, Jean-Paul Sartre, Simone de Beauvoir, and Allen Ginsberg. The members, noted Patricia Baker in *Fashions of a Decade: The 1950s,* "challenged established values and conventions" while adopting a dress code that included black dresses, slim black pants, black turtlenecks, black tights, flat shoes, and black berets. The new stretch fabrics were ideal for their wardrobes, creating clothing that fit comfortably close to the body. The look was exemplified by French singer, actress, and bohemian, Juliette Gréco, who became a Left Bank fashion leader in the 1950s. She originally wore black because she was poor, and the color was durable. Years later, when she could afford it, Gréco bought her little black dresses from Balenciaga.

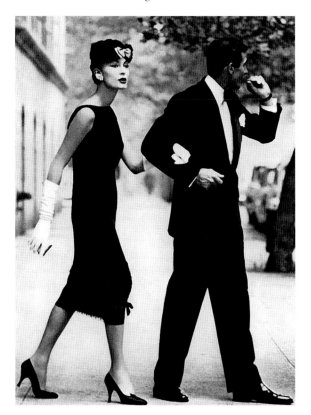

Left: A chemise dress in black crepe and a little black hat — another staple in a fifties woman's wardrobe.

Opposite: This black wool dress with a nipped waist and fitted torso is from one of DIOR'S final collections.

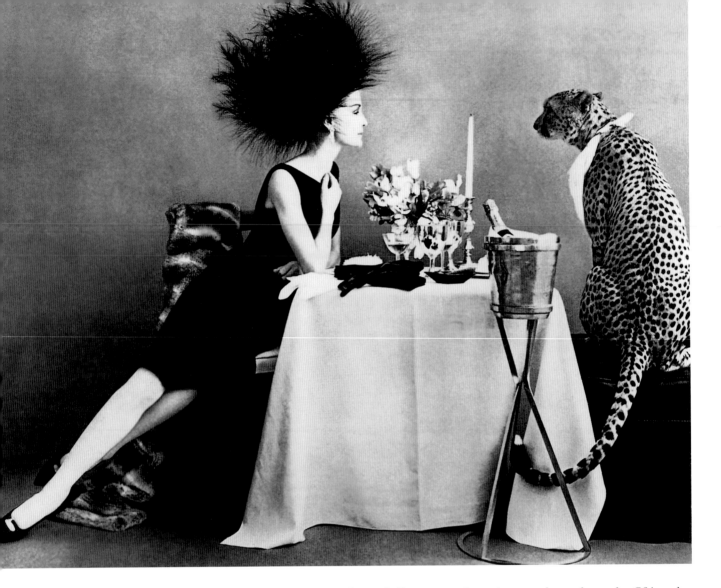

No matter what the shape, influence, or the price tag, throughout the fifties, the little black dress continued to be pervasive. As Ellen Melinkoff recalls in *What We Wore*, 1950s fashions were, "So intellectual, so avant-garde. No matter how many outfits like that we saw, we thought every one of them reflected a personal creativity on the part of the wearer. . . . The black top . . . and a frilly skirt became a nighttime uniform. One step away from the little black dress. . . . Black dresses were every woman's answer to the problem of what to wear. Every time there was any indecision, out came the black dress. If there were ten women at a party, nine would be in black. We maintained our individuality with a neckline variation or a bright scarf. But it was a futile attempt. The black always dominated. . . . Black was our crutch. Could we ever have imagined a time when we

Above: Anything was possible in the fashions of the sixties, including a little black dress with cowl neckline and bias skirt, a feathery pompom of a hat, and a very unusual dinner companion.

wouldn't have a pair of black shoes, when camel would take over as the dominant, yet neutral, shoe and purse color? Or that it would be possible to live without a black dress in the closet for any and all emergencies?"

Little Black Dresses and the Women Who Wore Them
Gloria Guinness

Born in Mexico, Gloria Guinness came from little money. It was said that her mother worked as a laundress. Guinness arrived in Paris in the thirties and, thanks to her incredible style and dark aristocratic beauty, quickly had the town at her feet. According to John Fairchild, publisher of *WWD* and *W* and chronicler of all things fashionable, "Gloria was ahead of Paris, she always has been." Guinness once recalled that, "Years ago when I was poor, I would buy a beautiful piece of jersey, cut a hole in the top and put it over my head and tie a beautiful sash around my waist. Everyone asked where I bought my dresses." She never lost her preference for minimalism. When she could afford it, by virtue of her marriage in 1949 to Loel Guinness, the English banking tycoon, she found her taste for little black dresses best expressed by Balenciaga.

The 1960s: The Really "Little" Black Dress

Through increased travel and expanded means of communication, the influences from a multitude of places suddenly converged in the sixties. *Fashions of a Decade: The 1960s* observed, "Everyone could dress up in the style of another country, another age, another sex. Anti-fashion had become the biggest fashion of all." A dress design could be inspired by clothing from Russia, India, South Africa, or outer space, via television's *Star Trek* or the movies' *2001: A Space Odyssey*. Couture's monopoly as fashion authority was breached; in order to remain relevant it had to reflect a broader vision.

In 1961, says Jane Mulvagh in *Vogue: History of 20th Century Fashion,* Balenciaga "contributed the most perfect little black dresses of the couture—slim, belted, wrapped, or drawstring fastened. The daytime curfew on the black dress ended at about six o'clock, after which it emerged in fashionable cafes and restaurants." Designers drew inspiration from a multitude of sources throughout the decade, but simplicity of line was common to most silhouettes. Yves Saint Laurent established his own house in 1962, with his finger firmly on the pulse of the young. Geoffrey Beene opened his business in New York in 1963, designing simple shifts and T-shirt dresses. Pop Art and Op Art influenced designers André Courrèges and Emanuel Ungaro in 1964, while Pierre Cardin and Paco Rabanne ushered in the "space age," creating hard-edged clothing in fabrics like plastic, chain-mail,

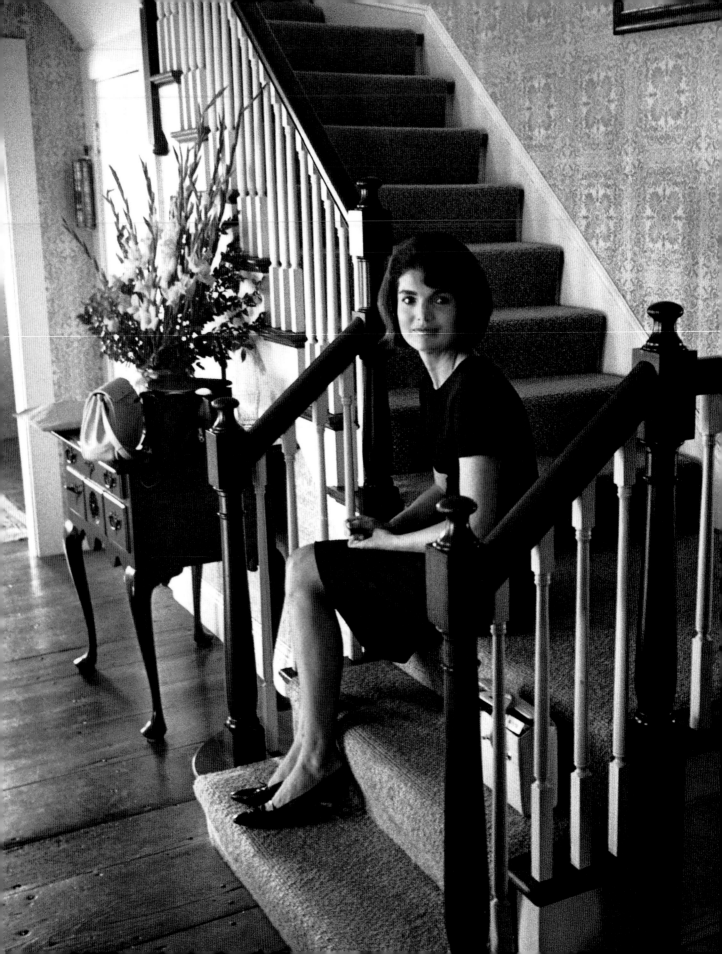

and patent leather. Said *Vogue*, "Some of the occasions designers apparently have in mind haven't happened yet."

While the French were busy determining trends, the United States was finding its own muse in the form of Jackie Kennedy. She began her reign as fashion arbiter on becoming First Lady, at age thirty-one, in 1961. Her youthful style was complimented by unfussy clothing that was easily copied by the adoring masses. And almost every woman in America wanted to look like her. Hubert de Givenchy said that, "She incarnated to perfection an ideal of beauty, American-style, composed of youth, charm and modernity." Although a great fan of Givenchy's work, she thought it inappropriate to wear clothing by a French designer while her husband was president. Therefore, most of her widely imitated wardrobe, from simple shifts to little black dresses, came from Oleg Cassini's New York studio.

The worlds of style and grief painfully collided in November 1963, when the nation collectively mourned the death of its slain young president, John Fitzgerald Kennedy. Although Jacqueline Kennedy Onassis will surely be remembered in a number of incarnations, the most pervasive image remains a solemn one—clutching the hands of her two young children, a grieving young widow standing tall and proud in a little black dress.

By the early sixties, British designers led by Mary Quant took center stage as fashion leaders for the ever-more visible younger generation. Even the little black dress would have trouble finding solid ground during the explosive "youthquake" to come. With the notable exception of Jackie Kennedy, the decade's main fashion influences arrived with the invasion of British mod and the Beatles in 1964 and ended with the American hippie.

Mary Quant went to art school in the hopes of becoming a teacher; instead she created fashion that would define a generation. In 1955, she opened a boutique called Bazaar in the popular King's Road of London. Unable to find items that appealed to her, the twenty-one-year-old decided to make them herself. The response to the clothing was immediate, and what seemed like an endless line of teenagers formed permanently outside the store. Quant launched the mini *before* the couture designers and successfully anticipated the desire for fashion with a sense of fun. Her clothes were inexpensive,

Opposite: In 1964, JACQUELINE KENNEDY sits on the staircase of her father-in-law's home in a simple little black dress.

Following Spread: For the ten best-dressed college girls of 1962, their little black dresses hit just above the ankle.

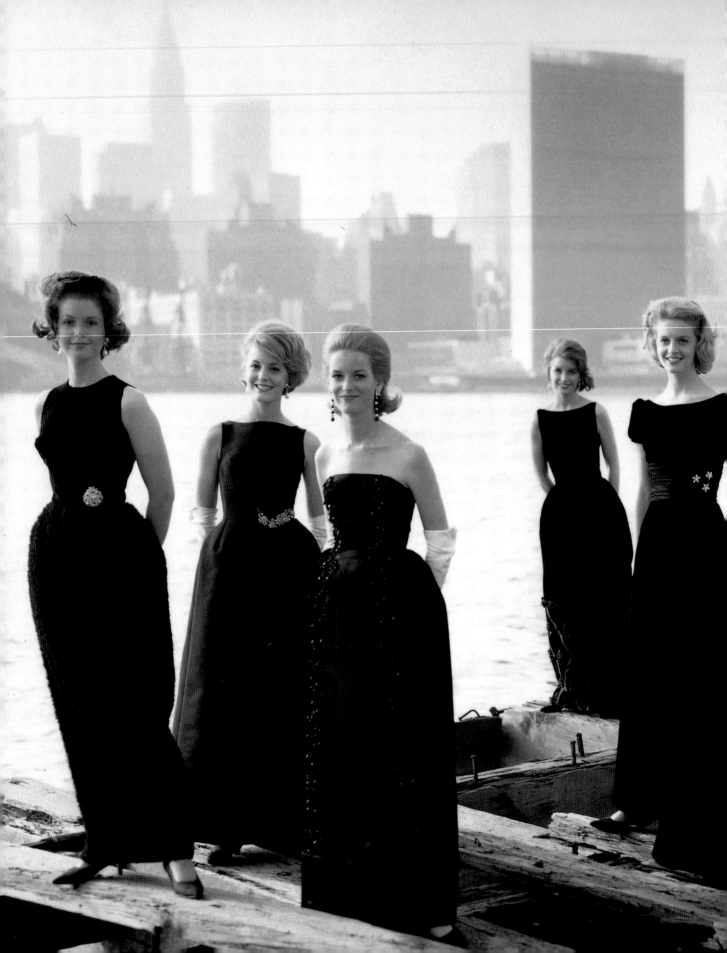

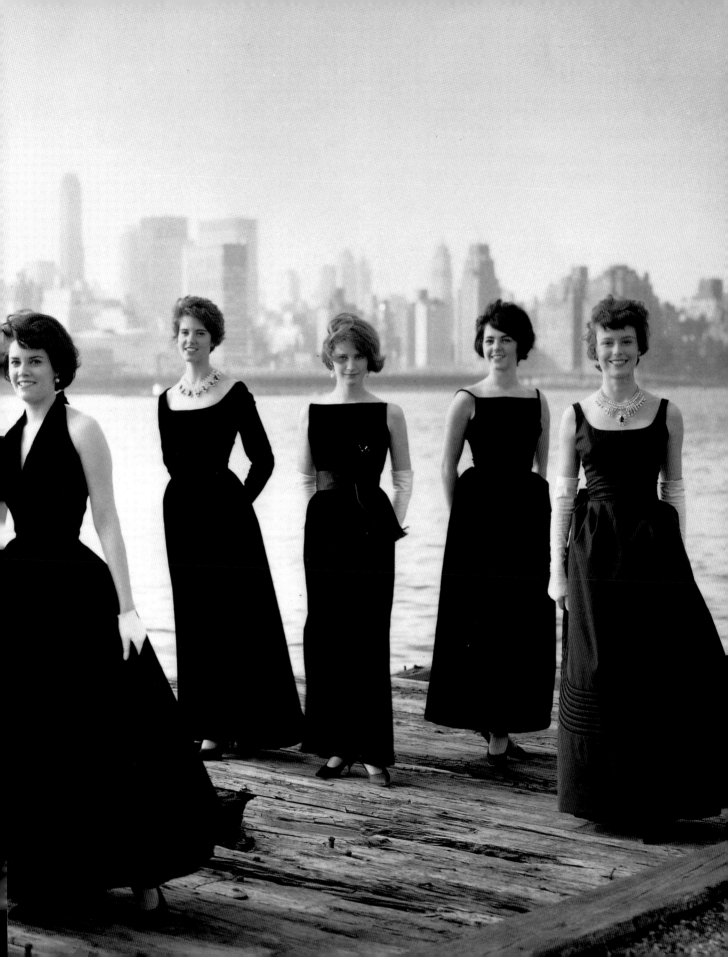

Above: Actress JANE BIRKIN sporting a transparent little black mini-dress in 1969.

Opposite: YVES SAINT LAURENT'S sheer black chiffon dress with ostrich plumage at the hips was quite a shock, even in 1967.

often made from easy-care synthetic fabrics, and perfect for young girls looking for something new. When the London Museum featured a Quant retrospective, the catalog reported that, "She was the first to understand and create a look for a new generation . . . she jolted this country and a sizeable part of the world out of its conventional ideas about clothes, that she blasted an opening in the wall of tradition through which other young talents have poured, that in every area of fashion she opened windows which had been sealed tight far too long."

Teenagers, with the help of fashion, were busy redefining themselves. In 1963, Betty Friedan published *The Feminine Mystique,* heralding the start of the women's movement. But just as it had done in the 1920s, fashion took its direction from the young. The new liberated woman dressed to look like a girl. Diana Vreeland described the perfect beauty of the time as possessing "the smallest calves; the straightest legs; knees like little peaches;

tiny, narrow, supple feet; rounded arms; and beautiful wrists and throat."

Because clothing now skimmed the body, the constricting foundations of the fifties were no longer necessary. New-and-improved stretch fabrics made bras more comfortable. Skirts were so short that tights had to be worn in place of stockings. Hats were now only worn by *women,* for special occasions. Hemlines began the decade just above the knee. By the mid-sixties, micro-minis in fabrics such as crochet, mesh, and chenille rose to mid-thigh. As a contrast to previous decades, by the 1960s, fashion's dictatorship had loosened its grip. According to *In Vogue,* "By 1965, the women at any smart party would be divided into two groups; half in the shortest skirts, half in full-length evening dresses, and neither feeling out of place."

Little Black Dresses and the Women Who Wore Them
Barbie

Since her birth in 1959—at 11½ inches tall—Barbie has often been called an American icon. Despite her well-known reputation as a clothes horse, there are few little black dresses in Barbie's extensive wardrobe. Why? It seems that black, a rather sophisticated color, is not a favorite of Barbie's youngest fans, whose first preference remains pink. For special occasions, however, Barbie has been known to wear a dress that was designed for her in 1964, called "Black Magic." It's a strapless (!) silk sheath with a coordinating tulle cloak, with which Barbie wears a three-strand pearl choker, matching bracelet, and short black gloves. The design for the dress was a reproduction of a favorite ensemble belonging to Ruth Handler, one of the co-founders of Mattel Toys.

Penelope Tree

Penelope Tree, the youngest daughter of Marietta Peabody, a former U.S. representative to the United Nations, had her unofficial coming-out at Truman Capote's infamous Black and White Ball in 1966. Tree was only sixteen when she captured the attention of the reigning bourgeois socialites, wearing a very modern, very little black dress. *Vanity Fair* reported that, "Draped in a black sleeveless, floor-length tunic slit up to her ribs and clinging to those few surfaces it covered, she was the wood nymph in the enchanted forest. Her stemlike legs were enveloped in sheer black tights topped by hip-hugger bikini briefs—an outfit purchased at the ultra-mod boutique Paraphernalia.

Opposite: BARBIE steps out for the evening in Black Magic, a strapless black silk sheath with coordinating tulle cloak and short black gloves, circa 1964.

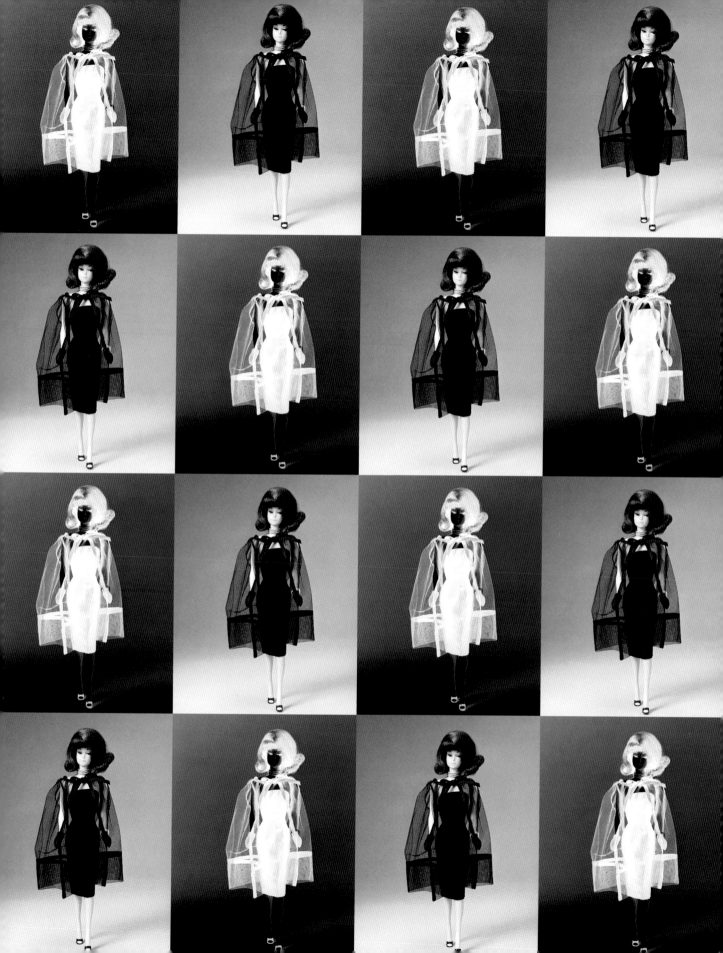

Her hair hung loose and straight, and her bangs nearly covered her eyes, which were revealed (once she removed her black batwoman mask) to be painted like Pierrot's."

The 1970s: The Little Black Dress from Soup to Just Nuts

The early 1970s was a time of fashion anarchy and general disillusionment. The Vietnam War raged on, the recession ended casual spending, and the oil crisis prompted fistfights at gas stations. The sixties' "summer of love" evolved into the seventies "me" decade. In response to the chaos, designers created clothing reminiscent of a more romantic time. Ruffled Victorian dresses with high-necked bodices by Laura Ashley and Ralph Lauren shared the sartorial spotlight with gypsy-influenced long, full skirts, big leather belts, and tasseled shawls by Saint Laurent.

Art Deco retrospectives and the film version of F. Scott Fitzgerald's *The Great Gatsby* inspired retro-Hollywood glamour. Glitter, glitz, and Lurex arrived with rock music's influence—David Bowie's Ziggy Stardust, Nona Hendryx of Labelle, and Roxy Music's haute style. Women wore satin hot pants paired with silky button-down shirts and sky-high platform shoes. Prints created by Italy's Emilio Pucci and Pop artists Roy Lichtenstein and Peter Max transformed simple silhouettes into eye-catching art. It seemed as if every trend found a place, but few little black dresses were sighted.

The start of the Middle East war in the fall of 1973 marked the beginning of a more conservative time. Simple, body-conscious silhouettes were the perfect foil for the decade's newly toned bodies. The most popular length for day dresses in the early seventies fell just above the knee in styles ranging from the shirtwaist to the easy T-shirt silhouette. The dresses, cut from matte jersey or new synthetics like slinky Qiana, were worn with high-heeled shoes, handbags slung casually over the shoulder, and an armload of bangle bracelets.

Designers reaching for a wider following made the couturier's atelier seem outdated. In 1975, writer Kennedy Fraser called it "a degenerate institution propped up by a sycophantic press." American ready-to-wear designers, including Anne Klein, Ralph Lauren, Halston, and Geoffrey Beene, were receiving as much attention, and more business, than the Paris couturiers. Calvin Klein renewed the concept of an interchangeable wardrobe—designing clothes that worked for the women who wore them.

Bill Blass became the first American-based designer to own his own business.

Opposite: PENELOPE TREE, at sixteen years old, dressed for Truman Capote's Black and White Ball in 1966.

A one-shoulder QIANA little black dress
from the seventies.

In contrast to the earlier system of designer dictates, Blass spent his time traveling
around the country, ensuring that his clothing met the needs of his customers. He
discovered that women were looking for something they could wear for an aperitif and
dinner afterward. He responded in spring 1975 with the little black cocktail dress—full-
sleeved, edged in lace, with a simple neckline, its hemline falling just below the knee.

Silhouettes loosened up as the decade progressed. The chemise and smock
dress superseded the shirtwaist; the "big look," introduced by the French, replaced those
that skimmed the body. The new styles were featured prominently in fashion publications,
but most women considered them neither practical nor flattering. They preferred the

ease of body-conscious clothing by Stephen Burrows and Halston. Meanwhile, *über*-minimalist Giorgio Armani prepared to open his first studio in Milan.

Punk arrived in America from England in 1976. Tainted by sadomasochism, the movement was a rejection of all that was traditional, conservative, and attractive. In addition to leather, studs, and mohawks, there was an obvious predilection for the color black. Although punk in its purest form never made it into the mainstream, its influence prompted Caroline Milbank to note in *New York Fashion* that, "Black is beginning to creep back into fashion for evening, but white, beige, pastels, and earth tones predominated formal clothes of the 1970s."

The 1980s: The Little Black Dress Accessorized

In hiding for most of the sixties and seventies, the little black dress was absent but not forgotten. With style influences now regularly emanating from around the world, even non-fashion made news. *The Preppy Handbook,* a primer on the conservative, old-monied look, offered this advice when it was published in 1980: "Don't wear black. With the exception of evening clothes and little black dresses." Editor Lisa Birnbach advised preppy women that they were "not supposed to have one until you're thirty. Still, it may be the most useful garment invented, so if you're clever you can start wearing it at age twenty-five. Adaptable to anything from a day at the office (worn with scarf) to a black-tie party (with pearls)."

The healthy economy of the early eighties brought shorter hemlines, while the health and fitness craze engendered skimpier silhouettes. Proud of their aerobicized bodies, women showed them off in very little, sculpted black spandex dresses by Azzedine Alaïa and Jean Paul Gaultier. Gym clothes, the bane of every schoolgirl, now muscled into everyday life, exercising influence over American ready-to-wear. Norma Kamali's collection of separates, cut from sweatshirt material and worn with leg warmers and flat boots, were as hip as they were comfortable.

When Lady Diana Spencer married the prince of Wales in 1981, she brought fantasy back to fashion. Republican luxury collided with British romance when the Reagans entered the White House, prompting Calvin Klein to recall that, "We all guessed on Seventh Avenue that glamour would be back and that we'd be doing glam evening dresses to show it off. Because the Reagans are Californian and California is pretty showy. It was a great change from the Carter administration, which was very much, you sewed your own dress!"

Many people felt that the clothing of twelve Japanese ready-to-wear designers, including Yohji Yamamoto, Kenzo, and Rei Kawakuba of Comme des Garçons, looked home-made. Nevertheless, their innovative collections seized fashion's center stage when

they showed their collections in Paris in 1982. Utilizing innovative fabrics, the garments were loosely constructed, devoid of ornamentation, and sometimes torn or wrapped. The colors of choice were mostly dark and neutral, prompting Kawakuba to admit that she worked mostly "in three shades of black." Although many women felt the clothing too extreme, eventually elements of the collections found their way into more mainstream designs.

By 1983, the broad-shouldered look, espoused by Claude Montana, Thierry Mugler, and Jean Paul Gaultier, had reached its apex. Women were bound by corsets, stuffed with padding, and squeezed into fitted, knee-length skirts. According to *Vogue: History of 20th Century Fashion*, the trend "amounted to a travesty of womanhood."

The eighties also bore witness to Chanel's alternative to fashion foolishness, this time created by Karl Lagerfeld, appointed as the House's new designer. Although Chanel herself may have objected to the opulence of his first collections, she would not have argued with the results. Lagerfeld brought new energy to the image and the clothing; Chanel's little black dresses would once again be among the most beautiful and sought-after in the world.

The burgeoning U.S. economy stoked the desire for extravagance, which eventually verged on the vulgar. Little black dresses were worn under pounds of accessories, both real and faux, the flashier the better. Oscar de la Renta and James Galanos furthered the "big-bucks" look, utilizing rich embroidery, pounds of beading, and the finest lace. Italian designer Franco Moschino poked fun at the lavishness by trimming his little black dress with stuffed teddy bears. As the decade progressed, there came with it the desire for something softer.

Richard Martin, curator of the Costume Institute at New York's Metropolitan Museum, thinks that the ultra-tailored "dress for success" formula of the late seventies and eighties has something to do with the continuing popularity of the little black dress. Women were required to dress like men, only in skirts. Their clothing choices and confidence expanded with their authority in the workplace. When Donna Karan went out on her own in 1985, her first collections seemed created specifically for working women tired of dressing in sexless, man-tailored suits. Just as men had a power uniform—the navy suit and yellow paisley tie—women needed something equally as potent, which allowed them to retain a sense of themselves as women. The little black dress fit the bill.

Opposite: Emancipation and the clothes to go with it. PALOMA PICASSO dances the night away in Paris at Le Palace in 1983.

The 1990s: Everything Old Is New Again

Smoking is illegal in most public places, sex can kill, and overspending is in bad taste. Perhaps as a reaction to the excess of the eighties, the nineties began with minimalists on overload. The first year of the decade saw mid-thigh little black dresses, sometimes with bondage-wear detail, worn with dark hose and high heels. Little black lace lingerie dresses were only for the best bodies and stoutest of heart, as they revealed far more than they covered. By 1992, the popular length was at the knee, and grunge-inspired dresses were being worn with combat boots. By 1993, women were wearing little black satin slip dresses that did double duty as nightgowns.

The color black was by now so pervasive that a little black dress *had* to be outrageous in order to stand out. The backlash began in the April 1994 issue of *Allure* magazine. Editor Linda Wells beseeched, "banish the black, wipe out the waif, dispel the doom." Her call was partially answered by the ladylike looks that appeared later that season. They were, of course, mostly available in black.

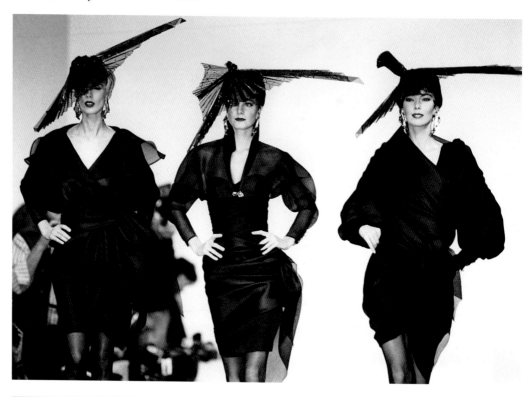

Above: Three models in "modern" little black organza cocktail dresses from the EMANUEL UNGARO spring/summer 1990 haute couture collection.

Opposite: FRANCO MOSCHINO makes a little black dress that earns its place atop a litter by circling the neck with teddy bears. From the designer's fall/winter 1988–89 collection.

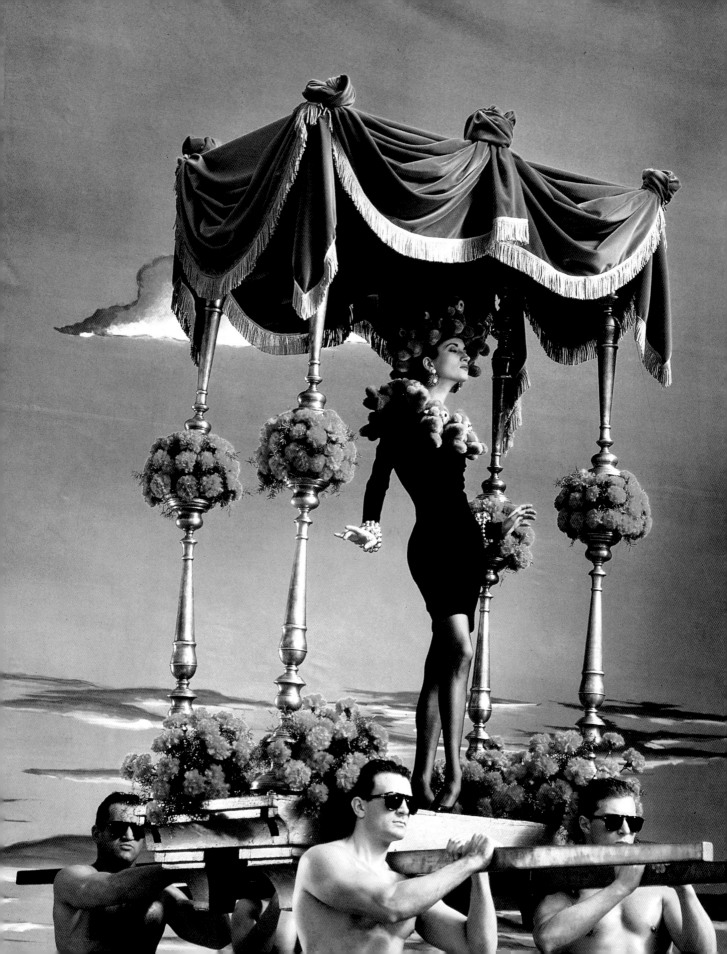

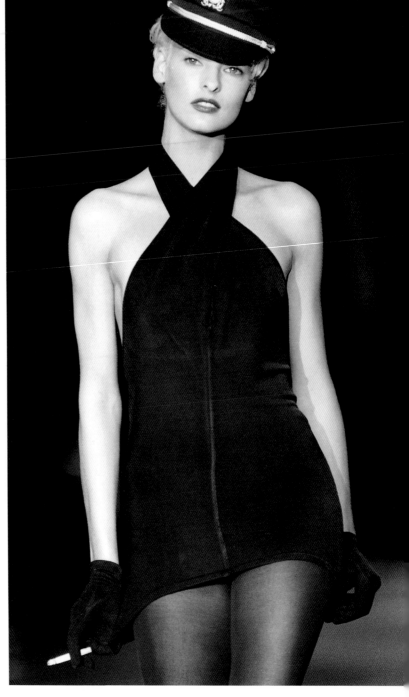

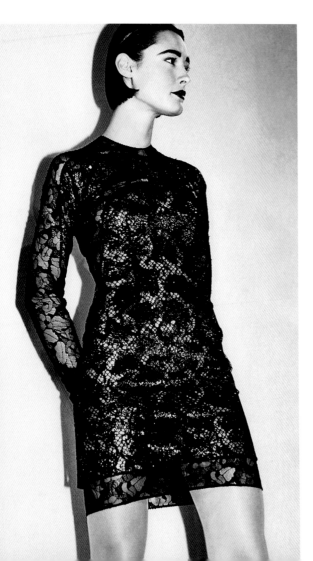

Above: LINDA EVANGELISTA
in a bare-shouldered, black
viscose mini-dress from KENZO,
fall/winter 1991–92.

Opposite: A KRIZIA dress
from 1995 highlights the body's curves
and gives new meaning to the term
"little" black dress.

Left: A sculptural little
black dress by GEOFFREY BEENE from
his fall 1990 collection.

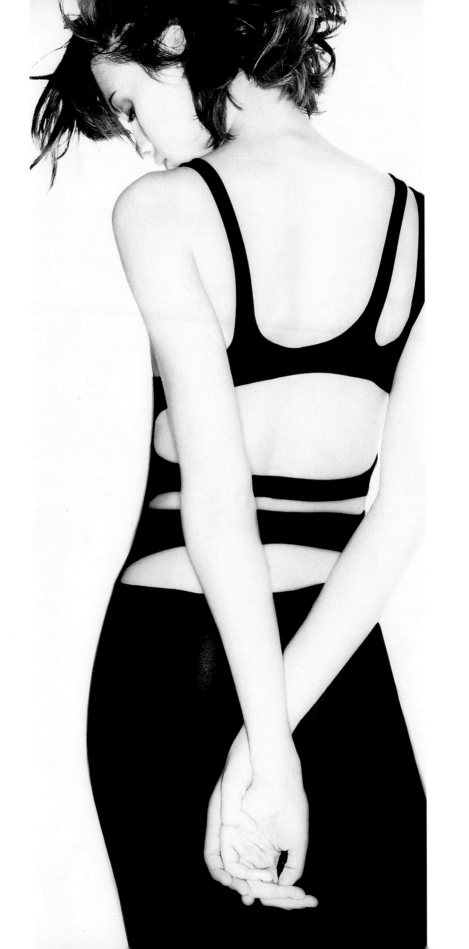

Calvin Klein showed simple little black sheath dresses that fell quietly to the knee. And although the July 1995 issue of *W* magazine asked, "Aren't you *really* ready to tear off the basic blacks that have been shrouding your body practically since the dawn of time?" the October 1995 issue of *Harper's Bazaar* answered that, "The next thing to think about is evening. The story begins with the little black dress. . . . Everyone should have one." Donna Karan would claim that, "The little black dress is the foundation of a woman's wardrobe."

The fall collections of 1995 marked the reemergence of the invaluable cocktail accessory, a.k.a. the little black dress. Sleeveless satin sheaths poured onto the runways, as bracing as a shot of Stoli. The dresses looked as modern as they did timeless, bearing more than a passing resemblance to their 1920s distant counterparts. The most important details—bare arms, a spare silhouette, a minimum of embellishment, and a knowing smile—were still very much in evidence.

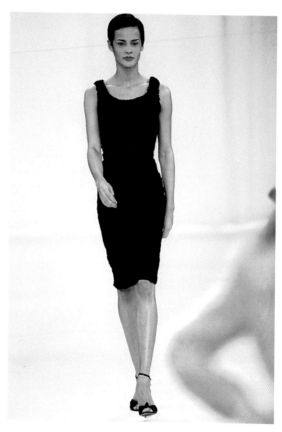

Above: The quintessential little black dress as designed by ISAAC MIZRAHI for spring 1995 features hand-embroidered satin ribbon on silk georgette.

Opposite: The cocktail dress lives! A square neckline updates this black crepe sheath from the RALPH LAUREN fall 1995 collection.

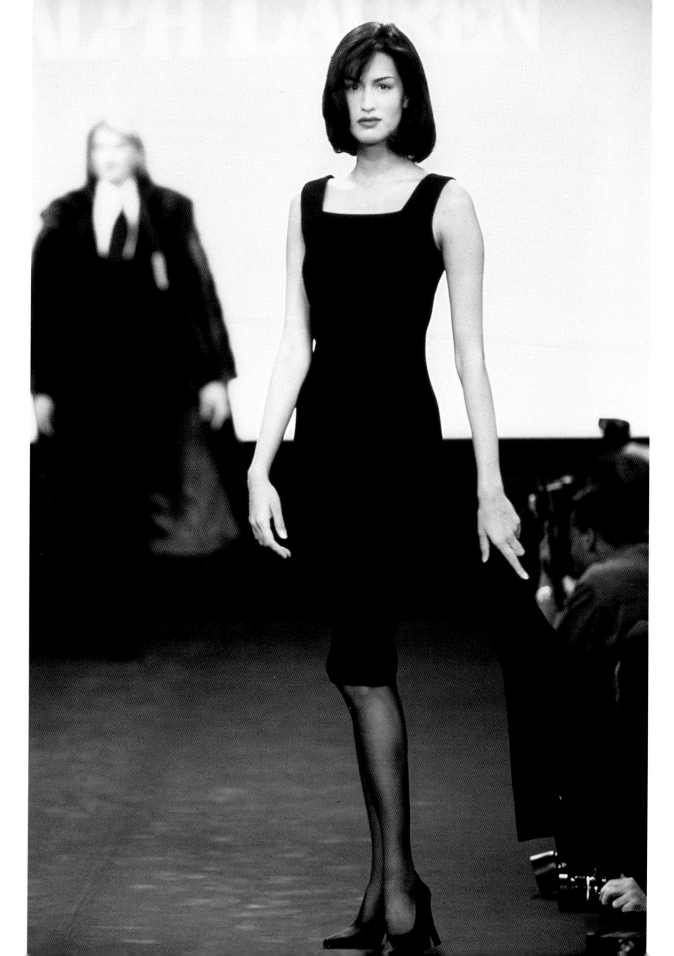

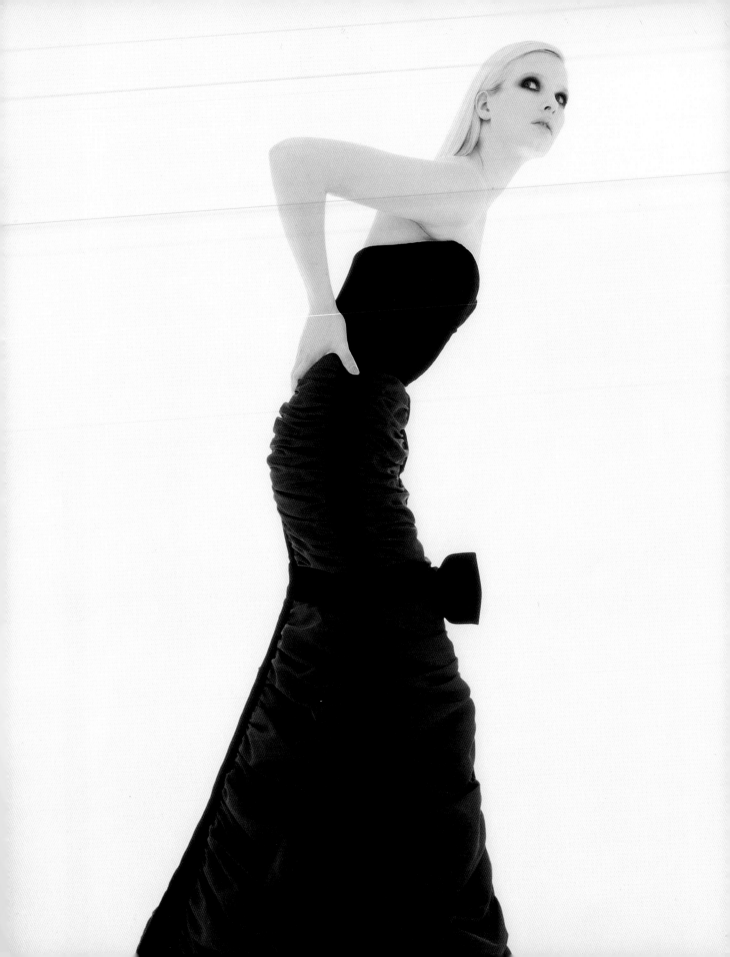

Perhaps it is ironic that a decade so hospitable to the little black dress should bear the passing of so many of those associated with it. Audrey Hepburn, the little black dress's ambassador of style, died in January 1993. A year later, Jacqueline Kennedy Onassis would also pass away. Hubert de Givenchy, the creator of perhaps the most recognized little black dress, retired in 1995. At his last couture collection he was saluted by his contemporaries and the young couturiers who came after him. Many of them wept.

Little Black Dresses and the Women Who Wore Them

Hillary Rodham Clinton

The little black dress, although by now an accepted fashion classic, still has the power to raise eyebrows, as evidenced by Hillary Clinton's photograph in the December 1993 issue of *Vogue* magazine. An editorial by Elena P. Brower in the December 25, 1993, issue of *The New York Times* stated that, "The controversy regarding Hillary Rodham Clinton's decision to be photographed . . . has become heated." From the ensuing uproar, you might have thought Mrs. Clinton was naked. In fact, she was wearing a black Donna Karan dress.

The First Lady's prior insistence that fashion was not important to her, that who you are was more important than what you looked like, was brought into question. In fact, the photograph is nothing if not the height of simplicity and restraint. The black velvet, off-the-shoulder dress was pulled up by Mrs. Clinton so that it hugs her neck like a wrap—hardly an overtly sexy look. The classic lines and stylish pedigree of the dress worn in the photo suggest that the First Lady understood the power of fashion. She may have underestimated, however, the power of the little black dress.

It was not the first time. When Mrs. Clinton wore Donna Karan's little black "cold-shoulder" dress at her first official state dinner in 1993, the photograph appeared on the front page of *The New York Times*. Knocked off by numerous designers at various price points, the black dress with the cutout shoulders was worn even by Republicans.

Elizabeth Hurley

When Elizabeth Hurley was photographed in 1994 wearing a little black dress by Gianni Versace, the British beauty's biggest claim to fame was that she was actor Hugh Grant's girlfriend. *WWD* called her "a woman who came to the public's attention in a couple of

Opposite: GIVENCHY'S last "little" black dress, from 1995, was a strapless gown with velvet bodice and trim and silk faille ruched skirt.

pieces of cloth and safety pins." Her consequent exposure, paired with a great body and naturally good looks, brought her a coveted makeup contract with Estée Lauder, movie offers, and an identity she could call her own.

Diana, Princess of Wales

Long before the scandals involving other men, eating disorders, and suicide attempts, Princess Diana used her extensive wardrobe to create a commotion. For Lady Diana Spencer's first public appearance with Prince Charles in 1981, she wore a strapless, low-cut evening dress, designed by Britain's Elizabeth and David Emanuel. It caused a sensation. Not only was it décolleté, it was black, a color that the House of Windsor usually reserved for mourning. In a flash, it recast a shy, nursery school teacher into a sophisticated woman, fit for a future king. (Or so we thought.) Following her separation from the prince, Diana continued to eschew royal fashion restrictions. An article about Diana from a 1995 issue of *In Style* magazine noted that, "Often in the evenings, she pulls out one of her collection of defiantly black dresses that would be barred from any funeral." The article goes on to quote British pop psychologist Dr. David Lewis as saying, "There's no doubt that she's using clothes as part of her armory of weapons in the war against the Windsors." What better shield than a little black dress?

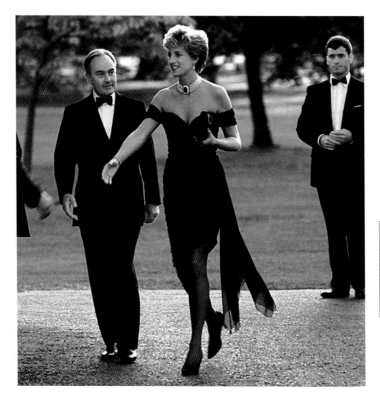

Left:
The always-fashionable
DIANA,
in a royal little
black dress.

Opposite:
ELIZABETH HURLEY
got "discovered" in this
very little black dress
by GIANNI VERSACE.

"The intoxication obtained from wearing certain articles of clothing can be as powerful as that induced by a drug."

—*Bernard Rudofsky*
The Unfashionable Human Body

Opposite: ELIZABETH TAYLOR wears a bodice-plunging little black dress in *Butterfield 8.*

Pop! Goes the Little Black Dress

Fashion does not exist in a vacuum. A "classic" cannot be designated as such until its echoes reverberate through film, music, and literature. Whether because the arts reflect their times, or because they influence them, the interchange between popular culture, timeless icons, and the fashion runway is ongoing. The little black dress is no exception.

The Little Black Dress on the Big Screen

Many of our most enduring images are formed at the movies, where the little black dress appears nightly as a wardrobe staple. It is ironic that in a medium that produces larger-than-life impressions, the little black dress should possess such an important role.

According to Jacqueline Herald in *Fashions of a Decade: The 1920s*, "Motion pictures began life as an inexpensive form of escapism, available to a far wider audience than the theater or ballet. In terms of dress, the medium had immense power—especially in the silent early years, when sharply defined costume and gestures were essential to the narrative. Black-and-white movies called for strong tonal contrasts in the clothes worn by the stars; the sparkle of beads and metallic finishes, and the movement and texture of feathers, could be picked up dramatically by the camera."

The little black dress provided strong visual contrast while quickly delivering a hint of the character's personality. A simple wardrobe change helped central casting define a poor shop girl, an efficient but stylish secretary, a sexy vamp, or a chic society matron, or it could merely single someone out from a sea of other actresses wearing lighter-colored dresses.

Cecil B. DeMille was one of the first directors to see the possibilities inherent in putting fashion and luxury on screen. The earliest motion pictures reflected the morality of the age and the public's taste. By the late teens, Victorianism was giving way to the Jazz Age, and DeMille reflected the change in his films. As noted by Richard Lawton in *A World of Movies: 70 Years of Film History*, "Sex and luxury—in a country that was discovering the first and had been deprived of the second—would be more likely to appeal." DeMille's favorite actress was Gloria Swanson, and in films such as *Male and Female* (1919) and

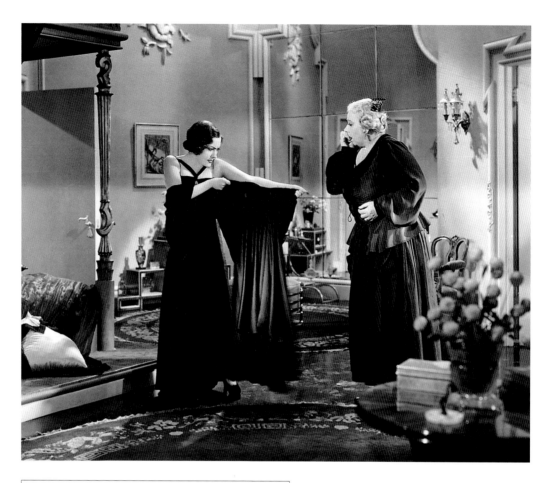

GLORIA SWANSON in the 1931 film
Tonight or Never wearing a CHANEL-designed costume.

Don't Change Your Husband (1919) she was decked out in lavish splendor. In contrast to the virginal heroines of the time, Swanson was a role model for the new emancipated women—smart, sexual, and savvy with a great sense of style. Here was someone who understood the power of a little black dress.

While movies were still being made in and around New York, actresses often persuaded local designers such as Hattie Carnegie to loan pieces from their collections for their films. Additional wardrobe was obtained from theatrical costume suppliers. By 1910, the exodus had begun to Southern California where clothing resources were not as bountiful. An increasing number of films, including period and fantasy pieces, made rentals expensive and inadequate. New arrangements had to be made, and so, like much of the world, the studio heads looked to Paris. Clothing by couturiers including Lucille and Elsa Schiaparelli were imported from Europe along with the newest film stars.

Chanel came to Hollywood at the invitation of MGM's Samuel Goldwyn in 1931,

her first official film credit appearing on Gloria Swanson's *Tonight or Never*. Swanson was at the height of her career, as was Chanel, and the potential for problems was obvious. Although both Chanel and Swanson were satisfied with the film's finished costumes, the partnership between Chanel and Hollywood was not considered a successful one. Some say that Chanel was unhappy; actresses were not as easily dictated to as fit models and society women. W. Robert LaVine notes *In a Glamorous Fashion* that Chanel "believed Hollywood overdressed its stars; she came to California determined to put her couture on the screen exactly as it was created for her clients in Paris. Instead, her understated garments seemed drab and unexciting when photographed and magnified on screen." After designing clothing for *Palmy Days* and midway through *The Greeks Had a Word for Them*, Chanel went back to Paris and couture.

The costume designer and the film studio were finally united in the early 1930s. The fact that most of the movie studios were owned and run by ex-members of the garment trade helped seal their successful alliance. Costume designers avoided the problem of keeping up with current styles by creating fashion of their own. In addition to emphasizing the leading lady's assets, the clothing had to work with the developing technology. The arrival of talking pictures in 1927 meant that rustling fabrics and jangling accessories had to be kept to a minimum. Hence, the arrival of sinuous satins and enveloping furs. When Technicolor first arrived in the mid-1930s, the little black dress was often a lifesaver. Many colors produced unnaturally garish shades, and darker hues proved easier to photograph.

By the 1930s, movies had tremendous reach, making international stars of actresses including Jean Harlow, Greta Garbo, Joan Crawford, Marlene Dietrich . . . and Betty Boop. A different kind of working girl, Betty Boop's wardrobe staple was short, strapless, and black. Making her debut in 1930 as a naughty and curvaceous jazz baby, she appeared in cartoons that played before feature movie attractions. As drawn by producer Max Fleisher, Betty had big eyes, a bow-tie mouth, and an unmistakable "boop boop be doop." She was the personification of the modern woman, a daring and assertive city girl with a charming sense of innocence. Betty was no homebody—she piloted planes, tamed lions, and made her own living. Sexual harassment, women running for president (in a short dress with garter showing; could this be where Donna Karan got the idea?)—Betty Boop dealt with issues *before* they were issues. Betty was the first female star who could do it all—drama,

Opposite: BETTY BOOP, the 1930s cartoon heroine, springs from the inkwell in her signature sexy little black dress.

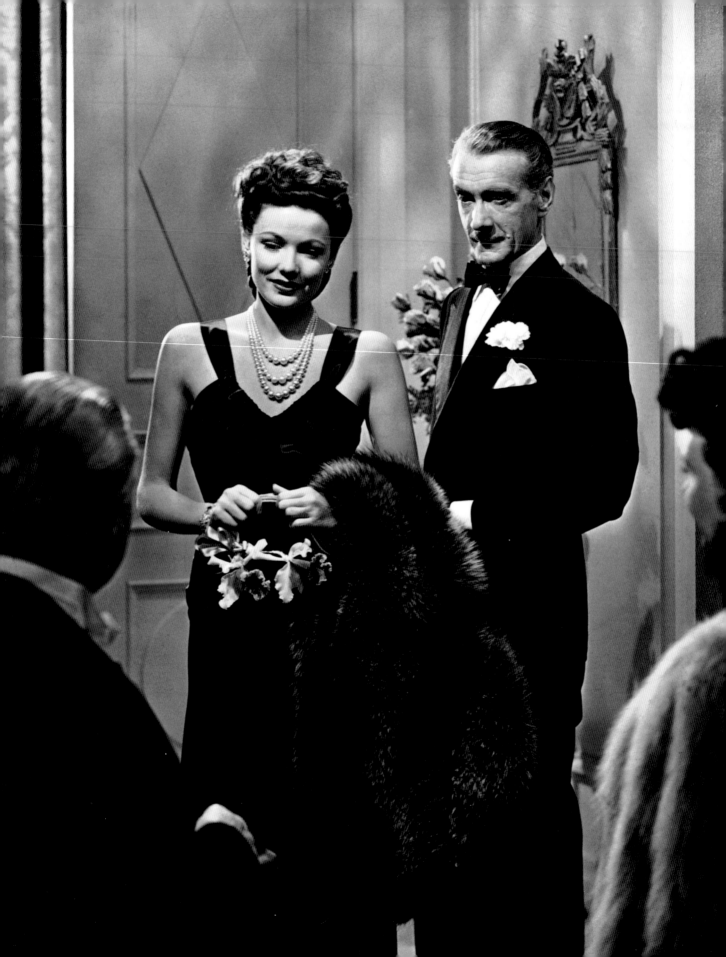

musical, and comedy. She even appeared as *Snow White*, in her signature little black dress, of course.

With the advent of the film star, fashion no longer took a back seat in movieland. Inevitably, the clothing created for the screen was adapted by the women watching in the audience. Positions were now reversed, and both New York and Paris took note of Hollywood's burgeoning fashion influence. Elsa Schiaparelli acknowledged the costume designer's reach, declaring, "What Hollywood designs today, you will be wearing tomorrow."

Many of the costume designers working in Hollywood had their roots in couture. Howard Greer's résumé included stints with Poiret and Molyneux in Paris and costumes for Broadway plays and Ziegfeld reviews. Greer became chief designer for Paramount in 1922, working with Cecil B. DeMille on *The Ten Commandments* (1923) and dressing actresses including Pola Negri. Greer left Paramount after his contract was up in 1927, reportedly because he was tired of having to think in terms of black-and-white film.

Travis Banton arrived at Paramount in 1924, after working as a designer for Hattie Carnegie in New York. Banton's sumptuous designs provided the perfect showcase for the screen goddesses of the period, and his lush little black dresses were worn by Louise Brooks in *The Canary Murder Case* (1929) and Marlene Dietrich in *Morocco* (1930).

The costume designer Adrian was arguably one of the world's best known. His influence was felt far beyond the hills of Hollywood. Having studied at the Parsons School of Design in New York and Paris, he arrived in Hollywood at MGM in 1928. Adrian's satin, bias-cut gowns—clinging surreptitiously to Jean Harlow—embodied the spirit of 1930s movie-star glamour. Adrian was not bored by the prospect of working in black and white as Howard Greer had been. He quickly mastered the challenges, using its shortcomings to his advantage when designing little black dresses for Greta Garbo in *As You Desire Me* (1932), Joan Crawford in *Mannequin* (1937), and Katharine Hepburn in *Woman of the Year* (1942). Adrian left MGM in 1939 and opened his own couture business in 1942. *Contemporary Fashion* noted that, "By the time . . . Adrian went into business for himself in the middle of World War II, his potential customers were already familiar with his work. For over a decade American women had been wearing copies of the clothes he had designed for some of the most famous movie stars of all time."

Opposite: The alluring black satin dress
GENE TIERNEY wore in the 1944 film noir
Laura symbolized sophistication.

The millions of people who attended the movies in the thirties and early forties were looking for a cheap escape. Grim reality overshadowed the Depression years; sophistication and beauty were in short supply. Even when a scene called for an actress to be poor, early stars retained their glamour. Depending on the fabric and cut, the dress could signify a woman of lesser means or a sophisticated lady with plenty of style. The little black dress became the standard bearer of chic sophistication and wealth, indicating, says designer Nolan Miller, "a character with taste and class in a scene when everyone else is overdressed." As a New York–based fashion editor in *Gentleman's Agreement* (1948), Celeste Holm's wardrobe includes little black dresses of drop-dead sophistication. A little black dress made it clear that the ghost of Constance Bennett in *Topper* (1937) was a rich, young socialite. It also emphasized Gene Tierney's unforgettable allure as *Laura* (1944).

Clothing designers often chose a little black dress for dramatic scenes so as not to distract from the actor. Dancing in a little black dress encouraged the viewer to pay closer attention to the dancer's footwork . . . or her curves. In the 1946 film *Gilda*, Rita Hayworth bumped her way through "Put the Blame on Mame" in a long, lean slip of black satin. The dress's strapless bodice seemed to defy gravity while a soft bow tied on one side only served to emphasize the swell of Hayworth's hips. For *Roberta* (1935), *Swing Time* (1936), and *Shall We Dance* (1937), Ginger Rogers wore a variety of little-black-dress silhouettes.

While most directors paid little attention to an actress's wardrobe, women were taking scrupulous notes. Movie audiences were predominantly female during the war years, and with little news emanating from Paris, film stars provided the perfect role models—incredibly beautiful and effortlessly stylish.

As the 1940s progressed, war films took precedence over glitzy costume dramas and little black bias-cut satin dresses were replaced by sturdier versions in wool. And so Bette Davis appears quite dignified in *Watch on the Rhine* (1943) and Joan Crawford somewhat restrained in *Possessed* (1947). The little black dress played its part by setting the stage for a less frivolous age.

Edith Head was responsible for more film wardrobes than any other costume designer and, as a testament to her talents, many of her clothes still look modern today.

Opposite: This slinky, long, little black dress made RITA HAYWORTH a star in the film *Gilda*. Designer JEAN LOUIS contrived the detail at the waist to hide Hayworth's pregnancy.

Following Spread: The little black dress faded into the background whenever GINGER ROGERS danced with FRED ASTAIRE. Here she wears a black satin dress by BERNARD NEWMAN in the 1935 film *Roberta*.

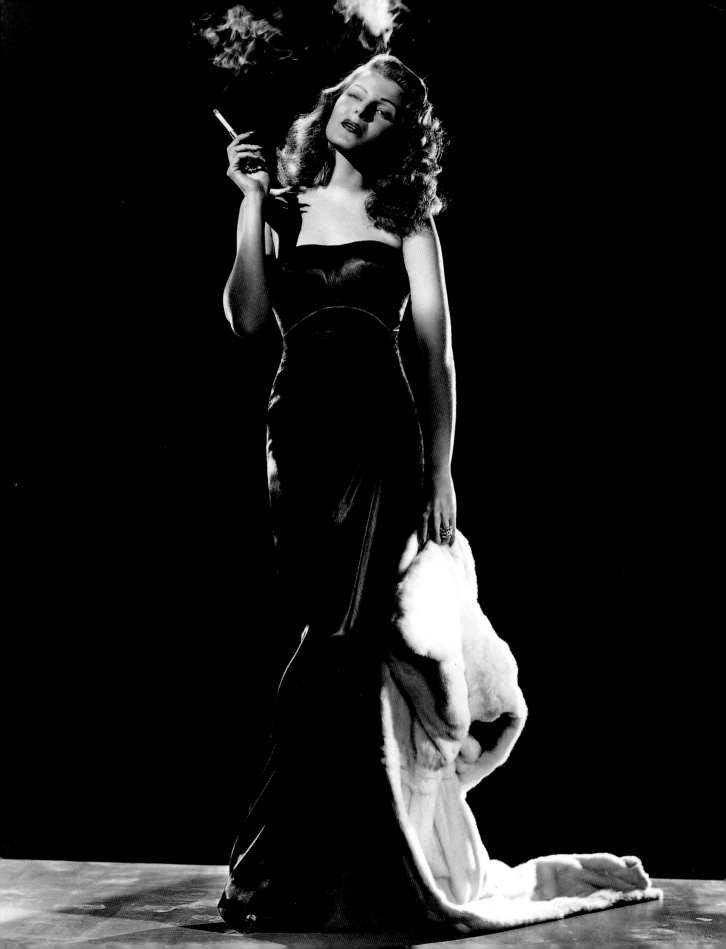

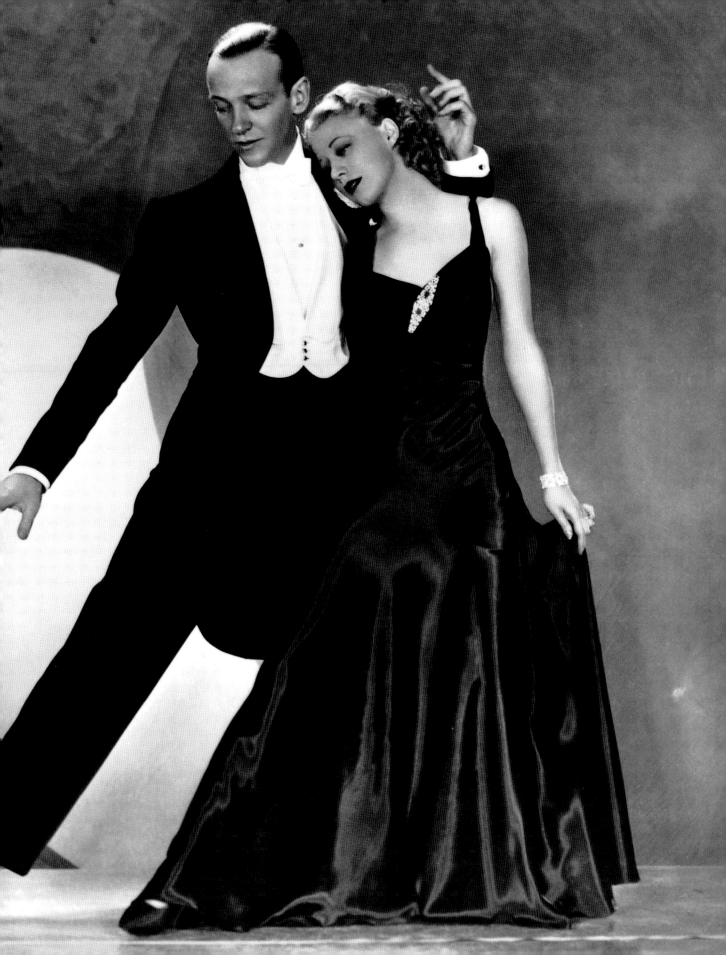

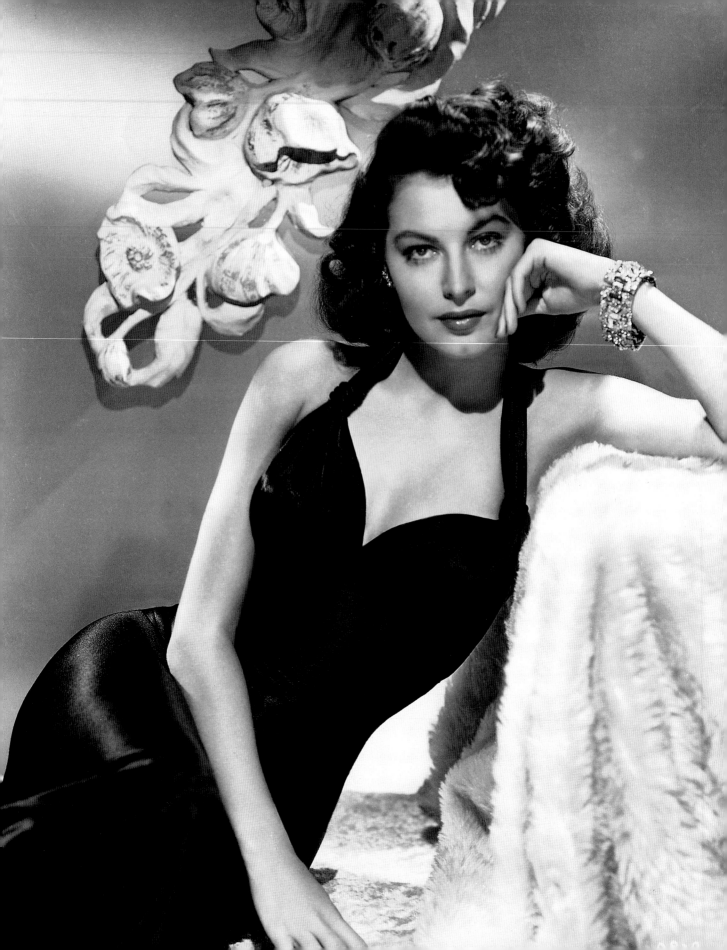

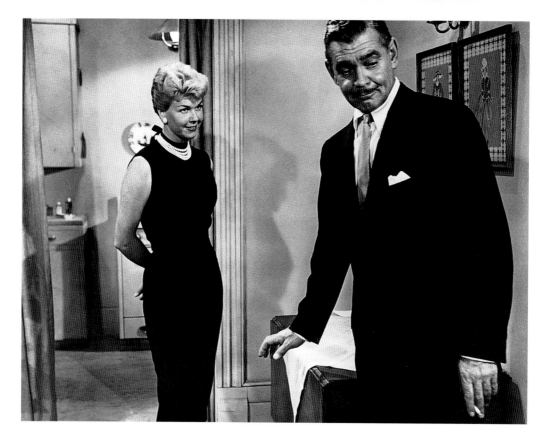

She began working at Paramount as a sketch artist in 1924 and succeeded Travis Banton, working primarily on B pictures, Paramount's main stock-in-trade at the time. According to *Contemporary Fashion*, "Head had no formal training in design and she took care to work within what she saw as her limitations. She might never be considered a couturier, but she could—and did—become a tastemaker. Thus, while contemporaries Erté and Adrian came to be known for gowns which epitomized fantasy and glamour, Edith Head made herself known for designing beautiful and flattering clothes which the movie-going public could easily imagine wearing." Her career at Paramount spanned sixty years and seven Academy Awards.

Movies, and movie-making, began to change as the fifties approached. *Life Goes to the Movies* notes that, "In 1946 the Hollywood establishment peaked. . . . The complacent feeling around the studios was that the prosperity and the system would continue forever. But a palace revolution was already in the making that would alter the industry forever. The portents of change were many: the advent of television, rising costs, a suddenly fickle public . . . their cumulative effect on the studios was devastating."

Above: In *Teacher's Pet*, released in 1958,
Doris Day wore a proper little black dress
designed by Edith Head.

Opposite: In the 1946 film *The Killers*,
Ava Gardner wore the slinky garb of a femme fatale.

FEDERICO FELLINI'S
LA DOLCE VITA
AN ASTOR RELEASE

61/257

Above: ANITA EKBERG is exuberant in black in the poster for *La Dolce Vita* (1960).

Opposite: MARILYN MONROE in a little black dress that functions as a second skin. Here she dances with TRUMAN CAPOTE at El Morocco in New York in 1955.

Sweet Charity

On and off the screen, the decade between the mid-fifties and the mid-sixties was a flamboyant one. Facing the growing popularity of television, movies competed with racier fare. Actresses were larger than life, and there was nothing better than a little black dress to emphasize their assets. Jayne Mansfield in *The Girl Can't Help It* (1956), Anita Ekberg in *La Dolce Vita* (1960), and Shirley MacLaine in *What a Way to Go* (1964) were all wrapped to perfection in little black dresses, which hugged every one of their curves.

Elizabeth Taylor became the poster girl for dangerous sex appeal when she appeared in the 1960 film *Butterfield 8*, based on the John O'Hara novel. The image in question features Taylor, a hooker who wants to go straight, draped over a piano in a little black dress with an overtly plunging neckline. Although the simple, sleeveless dress might have looked quite proper on another woman, Taylor's cleavage, high heels, and come-hither smile convey an altogether different meaning. Taylor won an Oscar for her performance.

Marilyn Monroe once confided to photographer Jean Howard that she called a black, tight-fitting, spaghetti-strapped sheath her "lucky dress." She wore a version of it in *Some Like It Hot* (1959) and a more modest interpretation

Opposite: JAYNE MANSFIELD brings in the morning milk wearing a little black dress and hat in the 1956 movie *The Girl Can't Help It*.

Left: The little black dress was a favorite of cinematic call girls: SHIRLEY MACLAINE dresses hers up with a tattoo in *Sweet Charity*.

for her last photo session for *Vogue* in 1962. As shot by Bert Stern, Monroe is seated, eyes cast down, her chin in hand. Her body is cloaked in a modest black dress, cut low enough on the shoulders to reveal her collarbone, the sleeves concealing her arms to her wrists. The waist of the dress is cinched; a wide skirt swells below—the demure lines of the dress give way to her more voluptuous ones. The blackness of the dress serves to emphasize the naked translucence of her skin, making her look like a vulnerable child—a provocative combination of purity and sophistication.

The Patron Saint of the Little Black Dress

"She raised the little black dress to an art form. She taught us how to wear it once and for all, not with fussy fuchsia print scarves, but with simple pearls, a black hat, and—did we dare—a long, black cigarette holder."

— Ellen Melinkoff (about Audrey Hepburn), *What We Wore*

The legendary qualities of the little black dress have been distilled over the years into one enduring image, that of Audrey Hepburn as Holly Golightly in the 1961 film *Breakfast at Tiffany's*. The film opens with the actress strolling down Fifth Avenue at dawn. Her column of black silk skims the impossibly litterless New York sidewalk; above-the-elbow gloves are worn with heaps of pearls and large black sunglasses. Cut to Hepburn's apartment, where, roused from her bed wearing a rumpled man's tuxedo shirt, she emerges three minutes later in a Givenchy-designed sleeveless shift with a self-tie sash, a flounce of feathers skimming her knees. Worn in almost every scene, the dress takes Hepburn from cocktails to Sing Sing to dinner at '21,' with merely a change of accessories. The dress, and Hepburn, manage to look different in every frame—yet these images, and this little black dress, have synthesized into the ultimate symbol of inestimable style and chic.

Author Truman Capote describes the narrator's first look at Holly Golightly: "It was a warm evening, nearly summer, and she wore a slim cool black dress, black sandals, a pearl choker. For all her chic thinness, she had an almost breakfast-cereal air of health, a soap and lemon cleanness, a rough pink darkening her cheeks. . . . She was never without dark glasses, she was always well groomed, there was a consequential good taste in the plainness of her clothes . . . that made her, herself, shine so." It is hard to believe that Audrey Hepburn was

Opposite: A black dress sets off
Marilyn Monroe's vulnerability in a 1962
Bert Stern photograph.

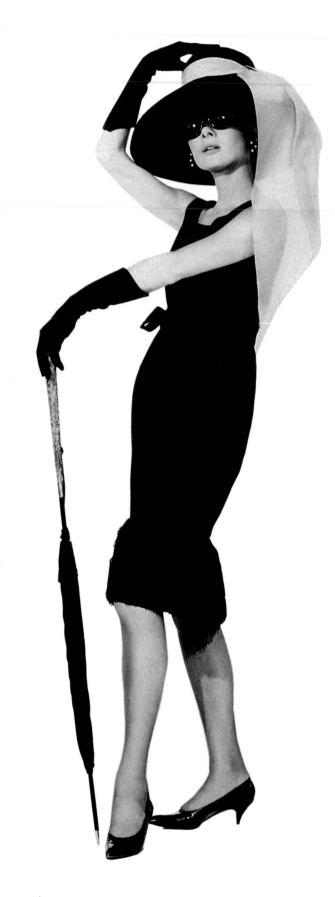

not the original choice for the role. That distinction fell to Marilyn Monroe, who declined the part. As lovely as Marilyn was, it is hard to imagine her shrugging on a Givenchy dress with the same unstudied nonchalance as Audrey.

Audrey Hepburn's relationship with Hubert de Givenchy began in 1953, with her second film *Sabrina*. Hepburn played a chauffeur's young daughter, who, courtesy of a trip to Paris and a wardrobe by Givenchy, returns a chic and sophisticated woman. In a 1962 interview for *Cine-Revue*, Hepburn related, "For *Sabrina*, Billy Wilder agreed to let me add a few Parisian costumes to the ones created by Edith Head. The dresses put forward by Hubert de Givenchy were divine. I felt as though I had been born to wear them."

Givenchy describes his first meeting with Hepburn in *Givenchy: 40 Years of Creation*, "The excitement of preparing the collection was at its peak. I was a great fan of Katharine Hepburn at the time, and, assuming that it was she who had come to visit me, I rushed forward to meet her. To my surprise, I saw Audrey, tall and slender in gingham-checked trousers and a tee-shirt. . . . I was immediately attracted by her lovely expression and exquisite manners. . . . She explained that she wanted me to design all her dresses for *Sabrina*; this was difficult right in the middle of preparing the collection but I did show her several models which seemed as though they had been made just for her." Givenchy shared the design duties for

Opposite: AUDREY HEPBURN in all her gamine glory, in a classic little black dress from the 1954 movie *Sabrina*. The film began her lifetime relationship with designer GIVENCHY, although this particular dress was credited to costume designer EDITH HEAD.

Left: AUDREY HEPBURN in the ultimate little black dress from the movie *Breakfast at Tiffany's*.

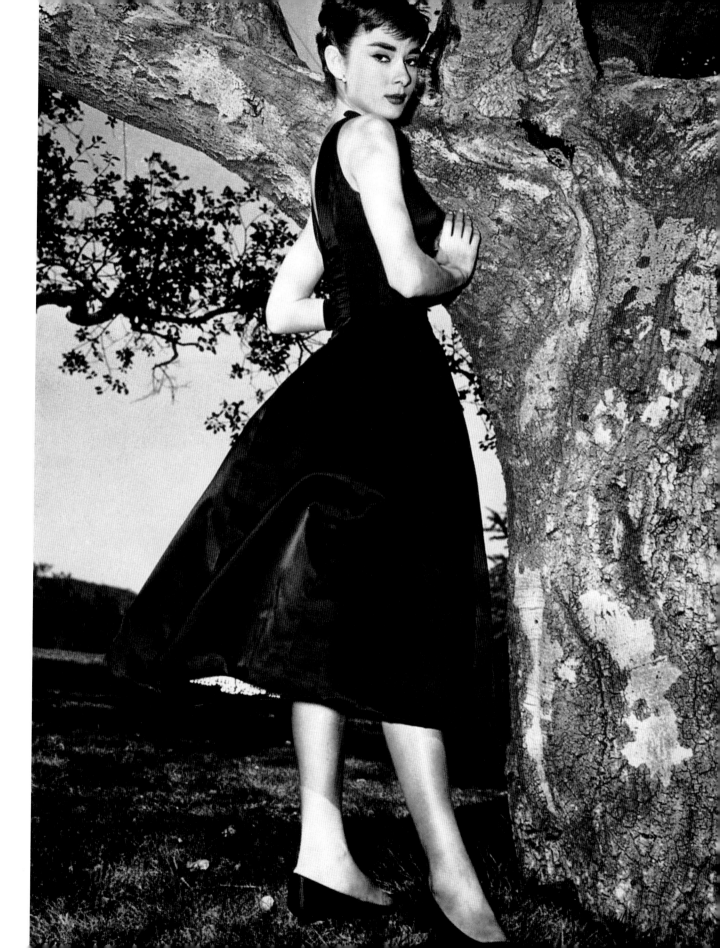

Sabrina with Edith Head, the studio's costumer. It was she who claimed ownership of the assiduously copied, cinched-waisted little black dress whose boat neckline tied at the shoulders, despite its Givenchy pedigree. It was also Head who would win the Academy Award for best costume design. She did not share the award with Givenchy.

Hepburn's growing popularity with the moviegoing public ensured that her professional association with Givenchy would continue. She next wore his clothing on-screen in the 1957 movie *Funny Face*. In this film, based loosely on the lives of photographer Richard Avedon and style-arbiter Diana Vreeland, Hepburn plays a beatnik whose metamorphosis is accomplished through love and a new wardrobe. Like *Sabrina*, this story also begins in the United States and travels to Paris, where Hepburn, transformed in a little black cocktail dress, forgoes turtlenecks and the bohemian life for Fred Astaire and a wardrobe by Givenchy. *Love in the Afternoon*, another movie with European locations and little black Givenchy dresses, shortly followed. But the most memorable pairing of actress and wardrobe would occur four years later with *Breakfast at Tiffany's*.

Hepburn spent a lifetime wearing Givenchy's clothes, on-screen and off. In addition to the little black dresses he created for her in *Breakfast at Tiffany's*, *Sabrina*, *Funny Face*, and *Love in the Afternoon*, she memorably wore his clothing in *Paris — When It Sizzles*, *Charade*, and *How to Steal a Million*.

By the mid-1960s, most of the major movie studios had stopped employing full-time costume designers. Edith Head left Paramount in 1967 after a reign of forty-four years. Producers now relied on freelance designers and wardrobers. Thirty years after her collaboration with Gloria Swanson, Chanel would design little black dresses for *Last Year at Marienbad* (1961) and *Boccaccio '70* (1962), neither of them Hollywood films.

Catherine Deneuve would be memorably dressed by Yves Saint Laurent in *Belle de Jour* (1967). Directed by Luis Buñuel, Deneuve played an exquisitely dressed but inhibited

housewife working as a hooker in the afternoons. When, at the end of the film, she has to pay penance for her sins, she does so in a buttoned-up little black dress, replete with white collar and cuffs. It makes her look, says another character in the film, like a "precocious schoolgirl."

The 1970s and early eighties were not a particularly good time for little black dresses—on or off the big screen. They did find their way into a few 1970s films, including a timeless, simple black sheath worn by Anne Bancroft in *The Turning Point* (1977) and a 1940s-style black dress worn by Faye Dunaway in the period film *Chinatown* (1974).

Upstaged by a riot of bright colors and prints for nearly a decade, the little black dress had regained its place in the spotlight by the mid-eighties. Its chameleonlike qualities suited Jennifer Beals as a glamorous creature of the night in *Vampire's Kiss* (1989) as well as they did Andie McDowell's frigid housewife in *Sex, Lies & Videotape* (1989).

Having come full circle, film wardrobers and costume designers are once again

Preceding Spread: ANITA EKBERG stretches languorously in a CHANEL design from the 1962 film *Boccaccio '70*.

Above Right: The little black dress worn by ANNE PARILLAUD in the 1990 film *La Femme Nikita*, and by DEMI MOORE (above left) as a million-dollar wife in the 1993 film *Indecent Proposal*.

taking their cue from current fashion. Movie women wear little black dresses for the same reason their real-life counterparts do. It is while trying on a slinky, cutout version that Demi Moore catches the eye of million-dollar man, Robert Redford, in *Indecent Proposal* (1993). After ripping off excess ruffles and puffs to reveal a perfect black sheath, Jamie Lee Curtis proceeded to seduce Arnold Schwarzenegger in 1994's *True Lies*. While most nineties women consider the little black dress ready for anything, Curtis further proved the point by wearing hers while dangling out of a helicopter. And even in the 1990s, the little black dress still retains a modicum of naughtiness. As a well-built young mistress in *The First Wives Club* (1996), it is Sarah Jessica Parker's skimpy dress of choice.

The Little Black Dress Off-Screen

Hollywood has come a long way from its heyday, when stars were required to act the part, both on and off the screen. There are no big studios to apply pressure if an actor does not "stay in line," and, consequently, the public is now wise to the fact that even movie stars have bad hair days. When a celebrity wants to look good but is unsure of what to wear, the little black dress still provides movie-star glamour with a minimum of movie-star fuss.

The annual Oscar Awards used to be a feast of fashion don'ts. Few now risk looking silly in front of millions of adoring fans. So in 1993 Liza Minnelli wore Donna Karan's black "cold-shoulder" dress, launching a thousand copies, and in 1995, best-actress winner Holly Hunter chose a body-skimming little black dress by Vera Wang. When "Oscar's Leading Ladies" were photographed in the April 1995 issue of *Vanity Fair*, six out of eight of the women featured, including Sophia Loren and Whoopi Goldberg, wore little black dresses. The glamour factor may have dimmed a bit, but the chicest and safest bet still remains a little black dress.

The Little Black Dress on Television

By virtue of their entrance into living rooms everywhere, television stars have had an equal, if not greater, impact on fashion than their big-screen counterparts. Television images, as opposed to those created by film, are of a more manageable size and are therefore seen as more accessible. Americans were introduced to television in the postwar glow of the forties. But it was not until the appearance of *I Love Lucy* in 1951 that television fashion picked up where film influence left off.

According to Patty Fox in her book *Star Style*, "Lucy hired her former RKO designer Edward Stevenson to shape the prim and proper shirtwaist dresses and blouses with loose-fitting trousers that she wore in most scenes. . . . Viewers not only adored Lucy, they went wild for her clothes. Dior's New Look dresses with their full skirts and fitted bodices

became an American mainstay once women saw Lucy's little-screen adaptions." Lucy liked to keep things simple, having once said, "I dislike anything excessive. It confuses me. I was happier when I had two dresses, both black."

When Mr. and Mrs. Ricky Ricardo visited Hollywood in their fourth season, Lucy set her sights on a dress by a well-known couturier at the time. She wanted a "Don Roper original." The dress in question was a simple black sheath, for the then-unheard-of price of $500. In the end, of course, Lucy went home with her little black dress.

Jane Wyatt, the doting wife on *Father Knows Best*, was another fifties fashion symbol. The picture of suburban cheerfulness, chic housewives frequently sported a little black dress while working their way through errands and evening cocktails. A television actor's wardrobe was usually purchased off-the-rack, and styles were comparable to current fashion. Consequently, throughout the fifties and sixties, the little black dress was a wardrobe staple in the closets of women from Eve Arden's *Our Miss Brooks* to variety game show panelists like Arlene Francis. Familiar with its Hollywood pedigree, Elizabeth Taylor

Above: The suburban mothers on fifties sitcoms—
like Jane Wyatt's character on *Father Knows Best*—often sported
the impeccable look of little black dresses with pearls.

donned an off-the-shoulder little black dress during her "Person to Person" interview with Edward R. Murrow in 1957.

Ten years after Taylor's televised chat, Marlo Thomas would wear a little black dress on the occasion of her husband, Phil Donahue's, final show. Thomas was no stranger to television audiences, having epitomized the mod ideal of the mid-sixties, appearing from 1966 to 1971 as *That Girl*. She played a young woman living on her own—one of the first television women to do so. Always out of work, Ann Marie still managed to wear the hippest styles of the period, including an occasional black mini-dress, paired with the requisite white tights and false eyelashes.

Prime-time soap operas, particularly *Dallas* and *Dynasty*, were the ratings stars of the mid-1980s, creating a rush for lavishly ornamented clothes. Jane Mulvagh writes in *Vogue: History of 20th Century Fashion* that, "Soap operas were a new fashion influence. Just as the cinema-goers of the thirties and forties had mimicked the wardrobes of Greta Garbo and Joan Crawford, so Joan Collins/Alexis and Linda Gray/Sue-Ellen became a source of inspiration." Nolan Miller, costume designer for *Dynasty*, created many little black dresses for the show's characters, with the exception of Joan Collins, who he observed, "never wore anything little. I used little black dresses in intimate situations, such as candle-lit dinners and, of course, for the requisite funeral and cocktail party. The little black dress was perfect when we wanted the character to look sincere."

The appearance of MTV caused an explosion louder than the shots fired at *Dallas*'s J.R. From its inception, MTV has pushed the television envelope with increasingly risqué clothing on its music video stars. Although the background musicians and singers in Robert Palmer's *Addicted to Love* video are restrained in their behavior, they fall into that same heavy-metal tradition of woman as sex object; the blacker and littler the dress the better.

In its far-reaching television career the little black dress has provided a key to the character and an accessible element of style, which, in the end, is pretty much what it does for the "real" women who wear it.

Opposite: MARLO THOMAS as we remember her best in a little black dress made especially for *That Girl*.

Above: The unforgettable backup talent in
their little black dresses in ROBERT PALMER'S classic
Addicted to Love music video.

Opposite:
JENNIFER ANISTON and COURTNEY COX,
two stars from the hit TV show *Friends*,
in little black dresses.

Creativity and the Little Black Dress

The ability to become part of the act has made the little black dress a favorite of artists in many mediums. When Martha Graham was born in 1884, ballet dancers wore costumes consisting of froufrou and rosettes. Graham wanted a wardrobe that cut away to the essentials while displaying the power and beauty of a woman's body. Soon after beginning her independent career in 1927, she produced her own version of the little black dress, cut on the bias from silk jersey and, because she could not sew, often held together with safety pins. Graham created a uniform whose primary purpose was comfort and ease of movement. Ron Protas, artistic director of the Martha Graham Dance Company, recalls her saying, "I don't want anything to detract from my bones." Years

later, designers would take note. Halston was inspired by Graham's clean sense of American style, while Donna Karan refers to her as a mentor. Martha Graham is acknowledged for creating a completely new, modern dance technique. Along the way, she designed a version of the little black dress in which to perform.

Another artist identified with the little black dress is Georgia O'Keeffe. Called by her biographer, Laurie Lisle, "one of the most original painters America has ever produced"

Above: The little black dress is the dress of choice for this group of TV and movie actresses.

Above: *Untitled* by ROBERT LONGO. 1980.
Charcoal and graphite on paper, 108 x 60 inches.
Courtesy the artist and Metro Pictures.
Photo by Pelka/Noble.

Opposite: MARTHA GRAHAM'S innovative style influenced
dancers and fashion designers alike. Here she wears a black dress of her own design while
rehearsing for *Revold*, her second independent recital, in 1927.

and "renowned for her fierce independence, iron determination, and unique artistic vision," she also almost always wore a simple black dress with a white collar, often at a time when other young women thought the color too severe. O'Keeffe's dresses were in direct contrast to the styles of the time—the overdone, corseted fashions of the late teens and early 1920s. O'Keeffe's mentor and husband, the photographer Alfred Stieglitz, was initially attracted to the painter by the distinct nature of her dress. When asked about her monotone clothing, O'Keeffe gave several explanations. According to Lisle, "Once she said that if she began to choose colors to *wear*, she would not have time to pick any to paint. Another time she explained that she was so sensitive to color that if she wore a red dress, she would feel obliged to live up to its flamboyance. She claimed she liked being cloaked in anonymity. . . . Deadly-serious black also served to transmit the message that she was not to be treated frivolously or flirtatiously. Also, she must have realized that if all her clothes were one color, they would match and she would achieve a look of maximum elegance with a minimum of time and money."

Legendary French singer Edith Piaf, nicknamed the "little black sparrow," wore little black dresses for many of the same reasons Georgia O'Keeffe did. Hubert de Givenchy thinks that they helped her fully express her emotions and talent. In *Piaf*, Margaret Crosland says of her style that, "her looks reflected no conventional glamour, but whenever she sang she grew beautiful. . . . She did not dance or reveal million-dollar legs, she could hardly have been a rival to the queen of the Folies-Bergère, preferring a plain black dress to ostrich plumes and strass." Piaf first sang in public in 1935 and wore black because, living in poverty on the street, she had no other clothing. Crosland further notes of Piaf that, "There was more to her style than the mere possession of a voice, [she had] a theatrical presence which in its way was anti-theater, anti-glamour. Her style was her own." That style included performing, for most of her career, in simple, little black dresses.

Opposite: Chanteuse EDITH PIAF, nicknamed "the little black sparrow," sings her heart out in one of her signature, unadorned little black dresses.

The Little Black Dress Goes Both Ways

It is fair to say that the dress is a classic expression of a woman's sexual identity—and the little black dress the badge of her sexual freedom. As the article of clothing most closely associated with "femaleness," it is not surprising that in the subculture of male cross-dressing, the little black dress shows up on its male/female wearer time and time again. In the 1959 film *Some Like It Hot*, Jack Lemmon dons a little black dress and a string of pearls in order to pass as a female musician—and in the process catches himself a rich husband. On the front cover of his 1995 book *Miss America*, shock jock Howard Stern leans provocatively forward, practically pushing falsies right out of his little black dress. In an illustration originally created for *Vanity Fair*, artist Robert Risko drew famously closeted cross-dresser J. Edgar Hoover in a fetching little black dress, his chest hairs just peeking out of the spot where his cleavage should be. When asked in a 1996 *Mother Jones* article on political cartoons about the inspiration for the drawing, Risko replied, "I just sort of put a simple, chic dress on him with a boa. With that face! That turtle face. A cross-dressing magazine for transvestites loved it, so they reprinted it." RuPaul, a latter-day Jayne Mansfield, exposes his best assets in a little black dress on the cover of his latest album, *Foxy Lady*.

Opposite:
TINA TURNER, all legs and a little black dress.

Following Spread: JACK LEMMON (left) in *Some Like It Hot*, and J. EDGAR HOOVER (right) as drawn by artist ROBERT RISKO finding out how the other half lives, in little black dresses.

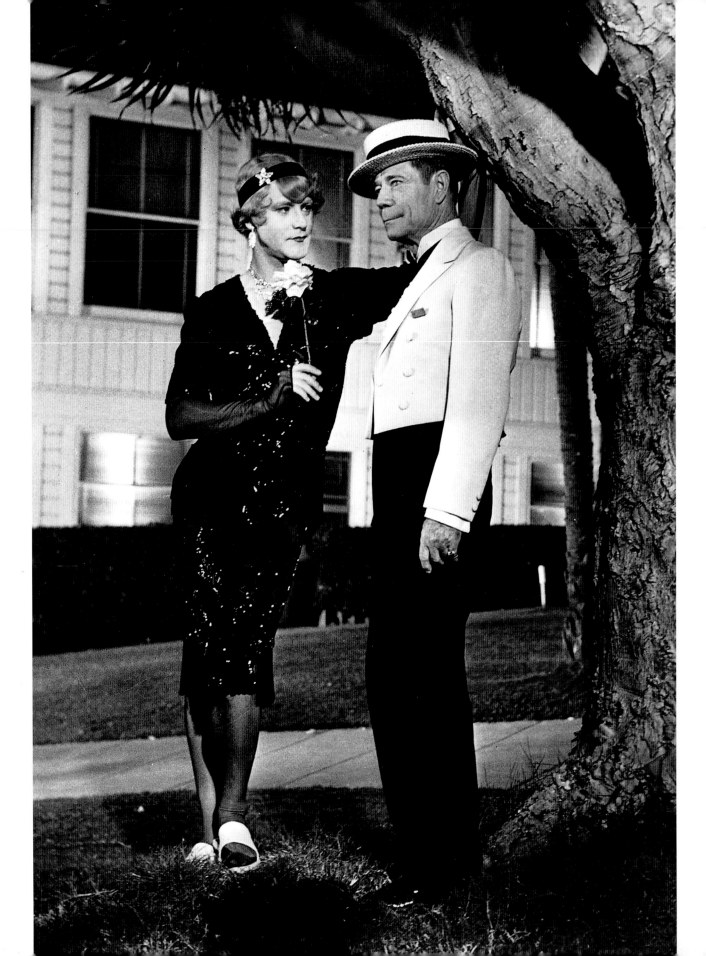

"I almost got into trouble at that party.... I think it was because of the dress."

—*Ilene Beckerman*
Love, Loss, and What I Wore

Shorthand for Chic

When the Sumerians appeared in 3500 B.C., clothing was already being used as a status indicator. Centuries later, fashion still provides clues to who a person is and who they hang out with, in addition to acting as a potential mate magnet. That is a whole lot of responsibility for a few yards of fabric and some buttons, but since its official debut in 1926, the little black dress has proven itself up to the task.

The reasons for the enduring success of the little black dress are many, including its ability to combine what is timelessly chic, currently fashionable, and enormously comfortable. A little black dress answers a variety of wardrobe demands and works in ways that other items of clothing do not. Being all things to many people may not be a good thing to aspire to personally, but it is not a bad attribute for a piece of clothing. In today's fast-moving world, when fashion changes at the speed of light, the little black dress has achieved the status of being above the fray. Considered by many to be shorthand for chic, a little black dress makes little concession to the current fad. A woman in a little black dress makes a statement without looking as if she has tried too hard.

From the cave man to the Gen X'er, clothing has consistently provided an identity. The need to conform to the habits of a like-minded group of people is innate. Richard Martin points out that, "One of the things people don't want to do is make a mistake. The little black dress bestows upon its wearer a sense of infallible correctness combined with self-assurance." Donna Karan likens a little black dress to a "security blanket." A woman can slip into one knowing that she will look appropriate for almost any occasion. The challenge is to fit in while retaining and expressing one's individuality. The little black dress is uniquely suited to fulfill both needs. Black's absence of color allows for limitless opportunities for self-expression. The little black dress becomes a canvas upon which the wearer can express her creativity and originality, while its "rightness" assures its wearer immediate acceptance. With a nod toward individuality, the little black dress provides the ideal setting for a perfect piece of jewelry or simply the woman who wears it.

Opposite: It's so chic, it takes you anywhere you want to go, in this case, poolside at the hotel Delano in Miami. Illustration by Maira Kalman.

Our most enduring images of women in little black dresses focus first on the wearer. The dress becomes merely a backdrop for the subject at hand. Hubert de Givenchy thinks that, "Because of its sober styling, the little black dress enhances the personality of the woman wearing it." Isaac Mizrahi thinks it "makes the woman the most important part of the equation and the clothing less so. More attention would be paid to clothing in another color." Vera Wang agrees and adds, "A woman can get lost in a bright colored dress." One of black's niftiest tricks involves its ability to draw attention in an indirect way, without overwhelming its wearer.

Grace Coddington, creative director at *Vogue* and a former model, thinks that, "Brighter, busier clothing has the power to dictate a woman's mood and consequently, her actions. A little black dress never overpowers; it allows a woman to play a whole range of parts." Certain styles are limiting, which is why women often find they have a lot of clothing but very little to wear. It is the woman who has to look businesslike in the morning and—in the same garment—dressed for dinner eight hours later, who determines what works . . . and what sells.

The color of a woman's dress does not just affect its wearer but also her audience. According to *The Psychology of Fashion*, "Most human interaction is structured in terms of the judgments people make of one another. Such judgments are influenced by an individual's clothing. . . . When personal information is lacking, appearance becomes one of the major means of deriving cues about a person." Which is fine, except when a woman wants to retain a sense of mystery, or when she is not sure what she wants to project. A little black dress does not enter the room before its wearer nor does it talk too much.

The ability to remain anonymous has made the little black dress an invaluable tool in the workplace. Lillian Eichler wrote in the 1921 *Book of Etiquette* that, "The woman who would be a success in business must remember that she cannot do justice to the business of the moment if she is wondering whether her skirts fall just right, whether her blouse is still crisply laundered, whether the colors she is wearing are not too bright." Seventy-five years later, Richard Martin puts it this way: "A woman in a white organza dress is a person who is not going to be taken entirely seriously. Instead of the business at-hand, people are likely to be thinking, 'who does her laundry?' There are many colors and styles which can be too seductive or even too feminine, in an old-fashioned sense. None of these feelings

Opposite: Legendary style-maker Diana Vreeland uses a little black dress to show off her fabulous accessories.

come up when a woman wears a little black dress." It is hard to project authority when wearing pink.

According to an essay by Glenn O'Brien in *Color of Fashion*, "Psychologists assert that sports teams with black uniforms are more intimidating, and they have research to back it up." The same intimidation appears to apply when a decisive woman wears a little black dress. Black is considered a power shade because it does not interfere with the wearer. A little black dress does not distract; it enhances. A warrior is better prepared for battle when her wardrobe is right.

The effectiveness of a little black dress is not solely bound to the office. Letitia Baldrige thinks that, "Because the little black dress is not conspicuous in its shape or fabric, it imparts a certain mystery, inviting a man to draw physically closer to see its hidden details." Baldrige recalls advice she received from *Harper's Bazaar*'s Paris editor, Mary Louise Bousquet, in the late 1940s: "Men love to be out with a woman wearing a little black dress because it allows *them* to shine." Forty years later, Grace Coddington echoes that advice: "A little black dress shows just enough, while allowing a woman's personality to show through. Many men don't want the woman they're out with to look obvious. They like to feel that a woman is keeping something private, for their eyes only." For those who would dispute that the perfect little black dress can conquer any man, at least part of the answer lies in the little black dress's ability to make a woman feel her best. When she doesn't have to worry about her clothing being right, she is free to enjoy herself—and that in itself can be very seductive.

Typically, the practical nature of the little black dress is overshadowed by its style. Long before Chanel made it chic, a black dress was prized for its durability—ideal for women of limited income, as it could be laundered less often and readily hid signs of wear. Even with a Gucci label, it still fulfills those functions today. A little black dress eradicates the fear of taxi-splash-stains-on-my-cool-new-white-shift and abolishes the I-dropped-chicken-salad-on-my-lap factor.

To the chic elite, the little black dress is the secret password of choice—a sensible item of clothing that almost always looks right. Linda Wells, editor in chief of *Allure* magazine, perfectly expressed black's practicality factor in a "Letter from the Editor." "Given fashion's fickleness, it hardly seems surprising that the people who work in its deepest trenches

Opposite: DONATELLA VERSACE
in a little black dress.

become flummoxed when dressing themselves. Fashion stylists settle on unfashion—shapeless sweaters, black pants, black raincoats. Like men in baggy Brooks Brothers suits, they've found a uniform that protects them from the risks of dabbling in trends." Or, as Donna Karan once put it, "trend overload." The little black dress solves the problem of keeping up with fashion while creating a fashion phenomenon unto itself.

Eleanor Lambert, fashion public-relations guru, believes that the little black dress is appropriate for any woman who has more important things to think about than her wardrobe. "There are still only 24 hours in a day. With a little black dress, you don't have to worry too much about the details." Big cities *are* urban jungles, and a little black dress performs as well as any army-issued uniform, protecting women from a multitude of dangers not found in the cleaner, slower-moving suburbs. This is not to imply that a little black dress is meant only for big-city women. On the contrary, a simple black dress is a nifty item to have on hand if you have children and frequent PTA meetings, being scrupulously correct and terrifically adept at hiding baby dribble.

Fashion has traditionally been the province of those with enough time and money to follow it. This naturally precluded the lower classes, who had more to worry about than the latest fashion news from Paris. It is only in recent decades that fashion has worked its way "up" from the street—interpreted by designers into expensive versions of the original item. High-priced designer labels now provide an indicator of who's who. In this respect, a little black dress is unique. It can be stitched up in inexpensive cotton or purchased with a designer label at Bergdorf Goodman. A little black dress can be procured by almost anyone who wants one. Unlike many of fashion's pricier status symbols, this item of clothing has always been very democratic.

Perhaps the clearest sign that the little black dress has worked its way into our collective subconscious is not its success on Seventh Avenue but its success on Madison Avenue. Advertisers continue to count on the little black dress to provide a sophisticated image that speaks to those buying everything from milk to perfume.

As we head for the twenty-first century, fashion no longer dictates, but it does still direct and inspire. Moving out from the shadow of fashion's mandates, women seem less inclined to adopt a style that does not work in their lives. Isaac Mizrahi thinks the whole idea of "fashion" is outmoded. What is important to him is the creation of beautiful

Opposite: Model NAOMI CAMPBELL cannot live without her daily glass of milk or her little black dress in this ad promoting milk.

You're probably going to hate me, but I've never dieted a day in my life.
Being so busy, I usually just grab something real quick. Which is why I love milk.
1% lowfat. With all the same nutrients as whole milk, it's just what my body needs.
Well, that and a closet full of ultrashort, supertight, little black dresses.

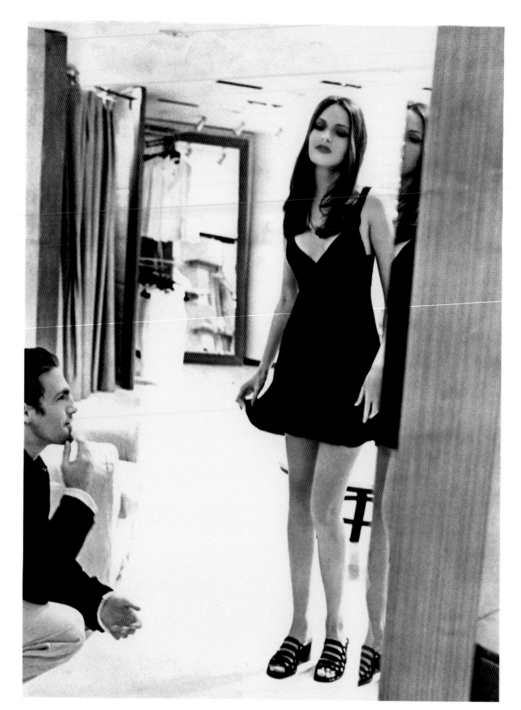

The little black dress that could.

Every wardrobe needs something captivating and comfortable, something that delivers every time. We have lots of dresses that can: prints, florals, knits and solids in every color. And the best little black dresses too. Dress by Kim & Kelly $295, shoes by Free Lance $185.

BARNEYS
NEW YORK

Beverly Hills Chestnut Hill Chicago Dallas Houston Manhasset Madison Ave. NY Seventeenth St. NY World Financial Ctr. NY Seattle Short Hills South Coast Plaza Tokyo Troy Westport Yokohama

clothes. Coco Chanel said pretty much the same thing, albeit several decades earlier: "Fashion changes—style remains."

Perhaps the core of what makes a little black dress so enticing remains buried in the mysteries of fashion and the deepest part of a woman's soul. Like an ardent lover, it can make her feel sexy and comfortable in her own skin. It flatters a woman's body, its color forgives extra pounds, and its spare silhouette makes every move appear effortless. A little black dress makes a woman feel pretty *and* comfortable; it makes her feel sexy *and* smart. It can be transformed, as can its wearer, by merely a change of accessories.

In the seven decades since its birth, the little black dress has become a uniform that expresses a modern woman's contradictions and celebrates her independence. It is emblematic of a woman's freedom of choice, her equal participation in the world, and her declaration that, this time, she is dressing for herself. The little black dress is an indication, rendered in silk, cotton, or wool crepe, of how far a woman has come from being merely a prettily dressed object. Today, when a woman's potential exceeds her limitations, the little black dress continues to be what she reaches for first.

Opposite: An ad from Barneys
New York showing a woman who dresses for herself.

Notes

Numbers refer to page numbers.

FRONT MATTER

3 "It is as if": Edna O'Brien, "I'll Buy Tomorrow," *Mirabella*, July 1994, p.153.

CHAPTER 1
The Birth of the Little Black Dress

12 "Scheherazade is easy": Steele, *Women of Fashion: Twentieth-Century Designers*, p.44.

14 "become the sort": Charles-Roux, *Chanel and Her World*, p.156.

15 "Chanel tended to": Etherington-Smith, *Patou*, p.30.

15 "Sport is the territory": Etherington-Smith, *Patou*, p.95.

16 "Patou made Chanel": Etherington-Smith, *Patou*, p.74.

16 "Since the war": *Harper's Bazaar*, editorial copy, March 1926.

18 "Chanel copied everything": *Harper's Bazaar*, August 1995, p.133.

20 "Simplicity is the keynote": De Meyer, "Mme. Chanel Tells Baron De Meyer Her Opinions on Good Taste," *Harper's Bazaar*, February 1923, p.96.

20 "The vast halls": Charles-Roux, *Chanel and Her World*, p. 20.

21 "In the world": Etherington-Smith, *Patou*, p. 19.

22 "To dress a woman": White, *Poiret*, p.39.

22 "There was scarcely": Etherington-Smith, *Patou*, p.53.

22 "Never before in": Tortora and Eubank, *Survey of Historic Costume*, p.291.

22 "Our books, our clothes": Hall, *The Twenties in "Vogue"*, p. 8.

22 "The feminine ideal": Steele, *Fashion and Eroticism*, p.239.

22 "Until the first": Tortora and Eubank, *Survey of Historic Costume*, p.291.

24 "I was able to": Steele, *Women of Fashion*, p. 42.

24 "Gabrielle Chanel stated": Charles-Roux, *Chanel and Her World*, p. 68.

24 "My establishment is": De Meyer, "Mme. Chanel," *Harper's Bazaar*, February 1923, p. 30.

CHAPTER 2
Black Magic

30 "Merely looking at": Lurie, *The Language of Clothes*, p.182.

30 "Like white, it": Lurie, *The Language of Clothes*, p. 188.

35 "Dresses before this": Karl Lagerfeld to the author, April 1996.

36 "We've forgotten—indeed": Ratcliff, *Sargent*, p. 235.

36 "She is ruined": Ratcliff, *Sargent*, p. 236.

36 "What can you": Wharton, *The Age of Innocence*, p. 39.

39 "She picked the": Wouk, *Marjorie Morningstar*, p. 15.

39 "We felt safe": Melinkoff, *What We Wore*, p. 33.

40 "The dress was": Beckerman, *Love, Loss, and What I Wore*, p.68.

40 "Of all the": Quant, *Color by Quant*, p.122.

41 "You'll never get": Heimel, *Sex Tips for Girls*, p. 160.

41 "Most American women": Leatrice Eiseman to the author, April and October 1995.

41 "Psychologically, the black": Kazanjian, *Icons: The Absolutes of Style*, p. 154.

41 "It's not black": Lagerfeld, *WWD*, January 1995, p. 1.

CHAPTER 3:
The Little Black Dress: A Classic in the Making

46 "Now that it was": Howell, *In Vogue*, p. 104.

46 "In the rue": Mulvagh, *Vogue: History of 20th Century Fashion*, p. 104.

47 "neither the talent": Mulvagh, *Vogue*, p. 86.

47 "The most talked-about": Steele, *Paris Fashion*, p. 248.

47 "In January 1930": White, *Elsa Schiaparelli: Empress of Paris Fashion*, p. 76.

48 "She knows how": Mulvagh, *Vogue*, p. 125.

48 "Curiously enough": Steele, *Women of Fashion: Twentieth-Century Designers*, p. 68.

48 "Looking back over": Steele, *Paris Fashion*, p. 250.

51 "insulting elegance": Howell, *In Vogue*, p. 68.

51 "as a scrubbed classical": Howell, *In Vogue*, p. 122.

51 "I'm nothing to look at": Tapert and Edkins, *The Power of Style: The Women Who Defined the Art of Living Well*, p. 97.

51 "The lighting is": Ross, *Beaton in Vogue*, p. 126.

55 "Don't forget, Claire": Steele, *Women of Fashion*, p. 104.

55 "By 1942": O'Donnol, *American Costume, 1915–1970*, p. 115.

55 "In France during": Mulvagh, *Vogue*, p. 325.

56 "Ten out of ten": "Brief Facts re The Little Black Dress," *Vogue*, 1 April 1944, p. 101.

56 "The New Look": Howell, *In Vogue*, p. 167.

56 "Was he mad": Charles-Roux, *Chanel and Her World*, p. 244.

56 "dressed in a": Tapert and Edkins, *The Power of Style*, p. 125.

59 "Valentina couldn't sew":
Fraser, "The Valentina
Vision," *Vogue*, March 1995,
p. 430.

59 "a period when": Contini,
5,000 Years of Fashion, p. 155.

60 "For much of this": Blum,
*Ahead of Fashion: Hats of the
20th Century* (catalog).

60 "the ultimate cocktail": Ibid.

63 "I am no longer": Howell,
In Vogue, p. 205.

63 "It was a time": Howell,
In Vogue, p. 204.

63 "A significant struggle":
Howell, *In Vogue*, p. 208.

64 "Almost every woman": Healy,
*Balenciaga: Masterpieces of
Fashion Design*, p. 2.

64 "Oh, but the": Healy,
*Balenciaga: Masterpieces of
Fashion Design*, p. 39.

64 "The most sophisticated":
Healy, *Balenciaga:
Masterpieces of Fashion
Design*, p. 18.

64 "In the teeth": Howell,
In Vogue, p. 205.

67 "challenged established
values": Baker, *Fashions of the
Times: The 1950s*, p. 83.

68 "So intellectual": Melinkoff,
What We Wore, p. 32.

69 "Gloria was ahead": Keenan,
*The Women We Wanted to
Look Like*, p. 24.

69 "Years ago": Keenan, *The
Women We Wanted to Look
Like*, p. 24.

69 "Everyone could dress":
Yvonne Connikie, *Fashions of
a Decade: The 1960s*, p. 57.

69 "contributed the most":
Mulvagh, *Vogue*, p. 267.

71 "Some of the occasions":
Howell, *In Vogue*, p. 284.

71 "She incarnated to": Hubert
de Givenchy, quoted in
"Remembering Jackie…,"
Town & Country,
July 1994, p. 64.

75 "She was the first": Carter,
*The Changing World of
Fashion*, p. 97.

75 "the smallest calves":
Mulvagh, *Vogue*, p. 291.

76 "By 1965": Howell, *In Vogue*,
p. 258.

76 "Draped in a black": Collins,
"A Night to Remember,"
Vanity Fair, July 1996, p. 137.

79 "a degenerate institution":
Fraser, "The Valentina
Vision," *Vogue*, March 1995,
p. 430.

81 "Black is beginning":
Milbank, *New York Fashion:
The Evolution of American
Style*, p. 246.

81 "Don't wear black": Birnbach,
*The Official Preppy
Handbook*, p. 128.

81 "not supposed to": Ibid.,
p. 131.

81 "We all guessed": Mulvagh,
Vogue, p. 347.

83 "in three shades": Steele,
Women of Fashion, p. 187.

83 "amounted to": Mulvagh,
Vogue, p. 384.

84 "banish the black": Wells,
"Letter to the Editor:
The Bright Side," *Allure*,
April 1994, p. 36.

88 "Aren't you *really*": editorial
copy, "All Fired Up," *W*, July
1995, p. 51.

88 "The next thing": editorial
copy, *Harper's Bazaar*,
October 1995, p. 215.

88 "The little black": Donna
Karan to the author,
March 1996.

91 "The controversy": Bower,
editorial, *The New York Times*,
December 25, 1993, p. 30.

91 "a woman who": editorial
copy, *WWD*,
19 April 1996, p.122.

92 "Often in the evenings":
Lague, "Diana Fabulous?
Absolutely!," *In Style*,
January 1996, p. 113.

92 "There's no doubt": Lague,
"Diana Fabulous?," *In Style*,
January 1996, p. 115.

CHAPTER 4:
Pop! Goes the Little Black Dress

96 "Motion pictures began":
Herald, *Fashions of a Decade:
The 1920s*, p. 36.

96 "Sex and luxury": Lawton, *A
World of Movies: 70 Years of
Film History*, p. 11.

98 "believed Hollywood
overdressed": LaVine, *In a
Glamorous Fashion: The
Fabulous Years of Hollywood*,
p. 76.

101 "What Hollywood designs":
Mulvagh, *Vogue*, p. 122.

101 "By the time": Martin, ed.,
Contemporary Fashion, p. 7.

102 "a character with taste":
Nolan Miller to the author,
February 1996.

102 "Head had no": Martin, ed.,
Contemporary Fashion, p. 221.

107 "In 1946": Scherman, ed.,
"Life" Goes to the Movies,
p. 235.

112 "lucky dress": Howard and
Waters, *Jean Howard's
Hollywood: A Photo Memoir*,
p. 227.

112 "She…raised": Melinkoff,
What We Wore, p. 38.

112 "It was a warm": Capote,
Breakfast at Tiffany's, p. 12.

114 "For *Sabrina*": Lepicard and
Train, *Givenchy: 40 Years of
Creation*, p. 85.

114 "The excitement": Lepicard
and Train, *Givenchy*, p. 85.

120 "Lucy hired her": Fox,
*Star Style: Hollywood Legends
as Fashion Icons*, p. 84.

121 "I dislike anything": Fox, *Star
Style*, p. 78.

123 "Soap operas were": Mulvagh,
Vogue, p. 390.

123 "never wore anything": Nolan Miller to the author, February 1996.

129 "I don't want": Martha Graham as quoted by Ron Protas, to the author, March 1996.

133 "one of the most": Laurie Lisle, *Portrait of an Artist: A Biography of Georgia O'Keeffe*, cover text.

133 "renowned for her": Ibid, cover text.

133 "Once she said": Ibid, p. 182.

133 "her looks reflected": Crosland, *Piaf*, p. 26.

133 "There was more": Crosland, *Piaf*, p. 31.

135 "I just sort": Heller, "Drawn and Quartered," *Mother Jones*, November/December 1996, p. 33.

CHAPTER 5:
Shorthand for Chic

140 "One of the things": Richard Martin to the author, September 1995.

140 "security blanket": Donna Karan to the author, March 1996.

140 "Because of its sober": Hubert de Givenchy to the author, September 1995.

142 "makes the woman": Isaac Mizrahi to the author, August 1995.

142 "A woman can get": Vera Wang to the author, April 1996.

142 "Brighter, busier clothing": Grace Coddington to the author, August 1996.

142 "Most human interaction": Michael R. Solomon, *The Psychology of Fashion*, p. 268.

142 "The woman who would": Eichler, *The Book of Etiquette*, p. 149.

142 "A woman in a": Richard Martin to the author, September 1995.

142 "Psychologists assert that": O'Brien, *Color of Fashion*, p. 237.

145 "Because the little": Letitia Baldrige to the author, October 1995.

145 "Men love to": Mary Louise Bousquet as quoted by Letitia Baldrige, to the author, April 1996.

145 "A little black": Grace Coddington to the author, August 1996.

145 "Given fashion's fickleness": Linda Wells in "Letter to the Editor: Fad Lands," *Allure*, July 1995, p. 24.

145 "trend overload": Bonnell, "Truth in Fashion," *Glamour*, September 1995, p. 193.

146 "There are still": Eleanor Lambert to the author, December 1995.

146 "Fashion changes": Tapert and Edkins, *The Power of Style*, p. 219.

Bibliography

"All Fired Up." *W*, July 1995, 51.

Bailey, Margaret. *Those Glorious Glamour Years*. Secaucus, N.J.: Citadel Press, 1982.

Baker, Patricia. *Fashions of a Decade: The 1950s*. New York: Facts on File, 1991.

———. *Fashions of a Decade: The 1940s*. New York: Facts on File, 1992.

Barnes, Colin. *Fashion Illustration*. London: Macdonald & Co., Ltd., 1988.

Barstow, Llewellyn Anne. *Witchcraze: A New History of the European Witch Hunts*. San Francisco: Pandora, 1994.

Beaton, Cecil. *The Glass of Fashion*. London: Weidenfeld & Nicolson, 1954.

Beckerman, Ilene. *Love, Loss, and What I Wore*. Chapel Hill, N.C.: Algonquin Books, 1995.

Bergler, Edmund. *Fashion and the Unconscious*. New York: R. Brunner, 1953.

Betts, Katherine. "Donna's New Age." *Vogue*, September 1990, 527.

Birnbach, Lisa, ed. *The Official Preppy Handbook*. New York: Workman Publishing Company, Inc., 1980.

Blum, Dilys E., curator. *Ahead of Fashion: Hats of the 20th Century*. Philadelphia: Philadelphia Museum of Art, 1993.

Bond, David. *The Guinness Guide to 20th Century Fashion*. Middlesex, England: Guinness Publishers, Ltd, 1988.

Bonnell, Kim. "Truth in Fashion." *Glamour*, quoting Donna Karan, September 1995, 193.

Boucher, François. *20,000 Years of Fashion*. New York: Harry N. Abrams, Inc., 1987.

Bower, Elena P. Editorial. *The New York Times*, 25 December 1993, 30.

"Brief Facts re The Little Black Dress," *Vogue*, 1 April 1944, 101.

Brooks, Louise. *Lulu in Hollywood*. New York: Alfred A. Knopf, Inc., 1982.

Brownlow, Kevin, with John Kobal. *Hollywood: The Pioneers*. New York: Alfred A. Knopf, Inc., 1977.

Burke, Betsy. *Good Taste in Clothes: Emily Post's Guidebooks for Homemakers*. New York: Emily Post Institute, 1963.

Capote, Truman. *Breakfast at Tiffany's*. New York: Vintage Books, 1993.

Card, James. *Seductive Cinema: The Art of the Silent Film*. New York: Alfred A. Knopf, Inc., Borzoi Books, 1994.

Carter, Ernestine. *The Changing World of Fashion*. New York: G. P. Putnam's Sons, 1977.

Charles-Roux, Edmonde. *Chanel and Her World.* New York: The Vendome Press, 1981.

Cohen, Scott. "Bill Blass." *Mirabella*, March/April 1996, 54.

Coleman, Elizabeth. *The Opulent Era: Fashions of Worth, Doucet, and Pingat.* New York: The Brooklyn Museum, 1989.

Collins, Amy Fine. "A Night to Remember." *Vanity Fair*, July 1996, 137.

Connikie, Yvonne. *Fashions of a Decade: The 1960s.* New York: Facts on File, 1990.

Contini, Mila. *5,000 Years of Fashion.* Secaucus, N.J.: Charwell Books, 1979.

Costantino, Maria. *Fashions of a Decade: The 1930s.* New York: Facts on File, 1992.

Crosland, Margaret. *Piaf.* New York: G. P. Putnam's Sons, 1985.

Cunningham, Phillis Emily. *Costumes for Births, Marriages, and Deaths.* New York: Barnes & Noble, 1972.

Davis, Fred. *Fashion, Culture, and Identity.* Chicago: University of Chicago, 1992.

De Givenchy, Hubert. *Town & Country.* July 1994, 64.

De Meyer, Baron. "Mlle. Chanel Tells Baron de Meyer Her Opinions on Good Taste." *Harper's Bazaar*, February 1923, 30, 96.

Dingwall, Eric John. *The American Woman.* New York: Rinehart & Co., Inc., 1956.

Duncan, Alastair. *American Art Deco.* New York: Harry N. Abrams, Inc., 1986.

Edwards, Anne. *The Queens Clothes.* London: Rainbird Publishing Group Ltd., 1976.

Eichler, Lillian. *The Book of Etiquette.* New York: Nelson Doubleday, Inc., 1921.

Elle, September 1995.

Engelmeier, Regina, and Peter Engelmeier. *Fashion in Film.* Munich: Prestel-Verlag, 1990.

Etherington-Smith, Meredith. *Patou.* New York: St. Martin's/Marek, 1983.

Fogerty, Anne. *Wife-Dressing: The Fine Art of Being a Well-Dressed Wife.* New York: Julian Messer, 1959.

Fox, Patty. *Star Style: Hollywood Legends as Fashion Icons.* Santa Monica, Cal.: Angel City Press, 1995.

Fraser, Kennedy. "The Valentina Vision." *Vogue*, March 1995, 430.

Gerson, Noel B. *Because I Loved Him.* New York: Morrow, 1971.

Glynn, Prudence. *Skin to Skin.* London: George Allen & Unwin, 1982.

Goldthorpe, Caroline, and The Metropolitan Museum of Art. *From Queen to Empress.* New York: Metropolitan Museum of Art, 1988.

Griffith, Richard. *The Movie Stars.* Garden City, N.Y.: Doubleday and Company, Inc., 1970.

Gross, Kim Johnson, and Jeff Stone. *Chic Simple: Clothes.* New York: Alfred A. Knopf, Inc., 1993.

———. *Chic Simple: Women's Wardrobe.* New York: Alfred A. Knopf, Inc., 1995.

Hall, Carolyn. *The Twenties in Vogue.* New York: Harmony Books, 1983.

Harper's Bazaar, March 1926.

Harper's Bazaar, July 1933, 51.

Harper's Bazaar, October 1995, 215.

Head, Edith, with Jane Kesner Ardmore. *The Dress Doctor.* Boston: Little Brown & Co., 1959.

Healy, Robyn. *Balenciaga: Masterpieces of Fashion Design.* Melbourne, Austral.: National Gallery of Victoria, 1992.

Heimel, Cynthia. *Sex Tips for Girls.* New York: Simon & Schuster Inc., 1983.

Heller, Steven. "Drawn and Quartered." *Mother Jones*, November/December 1996, 33.

Herald, Jacqueline. *Fashions of a Decade: The 1970s.* New York: Facts on File, 1992.

———. *Fashions of a Decade: The 1920s.* New York: Facts on File, 1991.

Hill, Frances. *A Delusion of Satan.* New York: Doubleday, Inc., 1995.

Hochswender, Woody. "Pins & Needles." *Harper's Bazaar*, September 1995, 464.

Hollander, Anne. *Seeing Through Clothes.* New York: Viking Press, 1978.

———. *Sex and Suits.* New York: Alfred A. Knopf, Inc., 1994.

Holt, Emily. *The Encyclopedia of Etiquette: A Book of Manners for Everyday Use.* New York: Doubleday, Page & Company, 1901–15.

Howard, Jean, and James Watters. *Jean Howard's Hollywood: A Photo Memoir.* New York: Harry N. Abrams, Inc., Publishers, 1989.

Howell, Georgina. *In Vogue.* New York: Penguin Books, 1975.

Joseph, Nathan. *Uniforms and Nonuniforms.* New York: Greenwood Press, 1986.

Jullian, Philippe. *La Belle Epoque.* New York: The Metropolitan Museum of Art, 1982.

Kazanjian, Dodie. *Icons: The Absolutes of Style.* New York: St. Martin's Press, 1995.

Keenan, Brigid. *The Women We Wanted to Look Like.* New York: St. Martin's Press, 1977.

Lagerfeld, Karl. *WWD*, January 1995, 1.

Lague, Louise. "Diana Fabulous? Absolutely!" *In Style*, January 1996, 113, 115.

Latour, Anny. *Kings of Fashion.* London: Weidenfeld and Nicolson, 1958.

Laver, James. *Costume and Fashion: A Concise History.* London: Thames & Hudson, 1995.

———. *Dress: How and Why Fashions in Men's and Women's Clothes Have Changed During the Past Few Hundred Years.* London: Murray, 1966.

———. *Modesty in Dress.* London: Heinemann, 1969.

LaVine, Robert W. *In a Glamorous Fashion: The Fabulous Years of Hollywood Costume Design.* New York: Scribner, 1976.

Lawton, Richard. *A World of Movies: Seventy Years of Film History.* New York: Delacorte Press, 1974.

Leese, Elizabeth. *Costume Design in the Movies.* New York: F. Unger Publishing Co., 1976.

Lépicard, José Marie, and Susan Train. *Givenchy: 40 Years of Creation.* Paris: Paris-Musées, 1991.

Lewenhaupt, Tony, and Claes Lewenhaupt. *Crosscurrents.* New York: Rizzoli, 1989.

Leymarie, John. *Chanel.* New York: Skira/Rizzoli, 1987.

"Limited Income." *Harper's Bazaar,* 15 May 1926.

Lisle, Laurie. *Portrait of an Artist: A Biography of Georgia O'Keeffe.* New York: Seaview Books, 1980.

Lorie, Peter. *Superstitions.* New York: Simon & Schuster Inc., 1992.

Lurie, Alison. *The Language of Clothes.* London: Vintage Books, 1982.

Mackrell, Alice. *Coco Chanel.* New York: Holmes & Meier, 1992.

Madsen, Axel. *Chanel: A Woman of Her Own.* New York: Henry Holt & Co., 1990.

Maeder, Edward, ed. *Hollywood and History: Costume Design in Film.* New York: Thames & Hudson, 1987.

Martin, Richard, ed. *Contemporary Fashion.* Detroit: St. James Press, 1995.

McDowell, Colin. *Dressed to Kill: Sex, Power, and Clothes.* London: Hutchinson, 1992.

McGrath, Charles. "It's Greek to Us." *The New York Times,* 25 February 1996, 54.

Melinkoff, Ellen. *What We Wore.* New York: William Morrow, 1984.

Menkes, Suzy. *The Windsor Style.* London: Collins Publishing Group, Grafton Books, 1987.

Milbank, Caroline Rennolds. *Couture: The Great Fashion Designers.* New York: Stewart, Tabori & Chang, 1985.

———. *New York Fashion: The Evolution of American Style.* New York: Henry N. Abrams, Inc., 1989.

Morris, Ira. *Glass of Fashion.* London: Pilot Press, 1947.

Mower, Sarah. "Hot Chanel." *Harper's Bazaar,* August 1995, 133.

Mulvagh, Jane. *Vogue: History of 20th Century Fashion.* London: Penguin Books, 1988.

Nunn, Joan. *Fashion in Costume, 1200–1980.* New York: New Amsterdam Books, 1984.

O'Brien, Edna. "I'll Buy Tomorrow." *Mirabella,* June 1994, 153.

O'Brien, Glenn. "Cocktails, Anyone?" *Harper's Bazaar,* August 1995, 48.

———. *Color of Fashion.* New York: Benney, Black & Bulzone/Stewart, Tabori & Chang, 1992.

O'Donnol, Shirley Miles. *American Costume, 1915–1970.* Bloomington: Indiana University Press, 1982.

"On the Street." *The New York Times,* 27 August 1995, 41.

Packer, William. *Fashion Drawing in Vogue.* London: Thames & Hudson, 1983.

"A Perfect Balance for Fall." *Harper's Bazaar,* October 1995, 215.

Quant, Mary. *Color by Quant.* New York: McGraw-Hill, 1985.

Ratcliff, Carter. *Sargent.* New York: Abbeville Press, 1982.

Ribiero, Aileen. *A Fashion in the French Revolution.* London: B.T. Batsford, 1988.

Robinson, Julian. *Fashion in the Thirties.* London: Oresko Books, 1978.

———. *The Golden Age of Style: Art Deco Fashion Illustration.* London: Orbis Publishing, Ltd., 1976.

Ross, Josephine. *Beaton in Vogue.* New York: Clarkson N. Potter, Inc., 1986.

———. *Society in Vogue: The International Set Between the Wars.* New York: The Vendome Press, 1992.

Rudofsky, Bernard. *The Unfashionable Human Body.* New York: Doubleday & Company, 1971.

Scherman, David E., ed. *"Life" Goes to the Movies.* New York: Time-Life Books, 1975.

Schnurnberger, Lynn. *Let There Be Clothes: 40,000 Years of Fashion.* New York: Workman Publishing, 1991.

Solomon, Michael R., ed. *The Psychology of Fashion.* Lexington, Mass.: Lexington Books, 1985.

Steele, Valerie. *Fashion and Eroticism: Ideals of Feminine Beauty from the Victorian Era to the Jazz Age.* New York: Oxford University Press, 1985.

———. *Paris Fashion.* New York: Oxford University Press, 1988.

———. *Women of Fashion: Twentieth-Century Designers.* New York: Rizzoli International Publications, Inc., 1991.

Swanson, Gloria. *Swanson on Swanson.* New York: Random House, 1980.

Tapert, Annette, and Diana Edkins. *The Power of Style: The Women Who Defined the Art of Living Well.* New York: Crown Publishers, Inc., 1994.

Taylor, Lou. *Mourning Dress.* London: George Allen & Unwin, 1983.

Tierney, John. "The Big City: Color Blind." *The New York Times*, 18 September 1994, 32.

Tortora, Phyllis, and Keith Eubank. *Survey of Historic Costume*. New York: Fairchild Publications, 1989.

Thienen, F. W. S. Van Frithjof. *The Great Age of Holland*. London: Harrap, 1951.

Versace, Gianni. *Bare Witness*. New York: The Metropolitan Museum of Art, 1996.

Visser, Margaret. *The Rituals of Dinner*. New York: Grove Weidenfeld, 1991.

Vreeland, Diana. *Romantic and Glamorous Hollywood Design*. New York: The Costume Institute, The Metropolitan Museum of Art, 1974.

Waugh, Norah. *Corsets and Crinolines*. London: B.T. Batsford Ltd., 1954.

Wells, Jane Warren. *Dress and Look Slender*. New York: David McKay Co., 1925.

Wells, Linda. "Letter to the Editor: The Bright Side." *Allure*, April 1994, 36.

———. "Letter to the Editor: Fad Lands." *Allure*, July 1995, 24.

Wharton, Edith. *The Age of Innocence.* New York: Macmillan Publishing Company, 1920.

White, Palmer. *Elsa Schiaparelli: Empress of Paris Fashion.* New York: Rizzoli, 1986.

———. *Poiret*. London: Studio Vista, 1973.

Winterburn, Florence Hull. *Principles of Correct Dress.* New York: Harper & Bros. Publishers, 1914.

Wouk, Herman. *Marjorie Morningstar.* New York: Doubleday, 1955.

WWD, 19 April 1996.

Photography and Illustration Credits

Numbers in bold refer to page numbers.

12, 14: Courtesy Chanel Inc.

15, 31, 62, 74, 75, 114, 115: © Archive Photos.

16 above left, 29, 32, 39, 40, 43, 94–5, 97, 99, 100, 103, 104–5, 106, 107, 108, 110, 111, 116–17, 118, 119, 121, 122, 134, 136: Courtesy Photofest.

16 above right, 22, 25, 33: Courtesy of *Harper's Bazaar.*

17; 63, ©1996: Courtesy Artist's Rights Society (ARS), New York/ADAGP, Paris.

18: Illustration by Charles Dana Gibson, 1867–1944/BETTMANN.

19: © Sevenarts Ltd. 1974.

20; 45; 49, Cecil Beaton, photographer, ©1941 (renewed 1969), *Vogue,* 7/1/41; **50, 53,** Blumenfeld, photographer, ©1952 (renewed 1980), *Vogue* 3/15/52; **57,** Horst, photographer, ©1940 (renewed 1968), *Vogue* 9/1/40; **58,** Blumenfeld, photographer, © 1952 (renewed 1980), *Vogue* 3/15/52; **60,** Cecil Beaton, photographer, ©1952 (renewed 1980), *Vogue* 5/1/52; **65,** Horst, photographer, ©1952 (renewed 1980), *Vogue* 3/1/52; **66,** William Klein, photographer, ©1957 (renewed 1985), *Vogue* 9/15/57; **67,** Karen Radkai, photographer, ©1957 (renewed 1985), *Vogue* 10/1/57; **68,** Leombruno-Bodi, photographer, ©1960 (renewed 1988), *Vogue* 11/1/60; **80,** Arthur Elgort, photographer, ©1976, *Vogue* 10/76. All photographs courtesy *Vogue* © by the Condé Nast Publications Inc.

26: © Edward Gorey 1996. Courtesy John Locke Studios, Inc.

30: All rights Stephanie H. Piro ©1995.

34: Archive Photos/Express Newspapers.

41; 148, thank-you to Travis Marshall. Courtesy of Barneys New York.

70: UPI/BETTMANN.

72–3: Howell Conant, photographer. Courtesy *Glamour.* ©1962 (renewed 1990), *Glamour,* 8/62.

77: Courtesy Mattel Inc.

78: © Henry Grossman.

82, 86 left, 139, 143, 144: Roxanne Lowit ©.

84, 86 above: Reuters/BETTMANN.

85: Courtesy Moschino.

87: Photographer, Nick Knight; Hair, Julien D'Ys; Make-up, Pat McGrath.

88: Courtesy Isaac Mizrahi.

89: Courtesy Polo Ralph Lauren.

90: © Patrick Demarchelier.

92, 93: Colin Mason/London Features Int'l LTD/USA.

109: Corbis/BETTMANN.

113: ©1982 Bert Stern.

124: Video produced by Terence Donovan.

125: Archive Photos/Warner Bros.

128–9: Photo by Troy Word for *Glamour* magazine.

131: Photo by Soichi Sunami.

132: Archive Photos/Archive France.

141: Courtesy Maira Kalman.

147: ©1996 Annie Leibovitz/Contact Press Images.

"The consciousness
perfectly
a peace such as

of being
dressed may bestow
religion
cannot give—"

—Herbert Spencer